PENGUIN HANDBOOKS

How to Draw the Human Head

Louise Gordon is a graduate of Toronto Teachers' College, of Queen's University, Kingston, Ontario, and of the University of Toronto, where she qualified in the three-year course of Art as Applied to Medicine. A member of the Canadian Academy of Medical Illustrators, she was lecturer and a member of the staff at the University of Toronto for eight years and in addition was staff artist at Sunnybrook Veterans' Hospital. For some years she worked as a free-lance artist on several of the leading medical textbooks in anatomy, surgery, and histology. For over ten years Louise Gordon has worked in fine art and as a part-time teacher. Until recently she taught Anatomy and Life Drawing at the Sir John Cass College of Art, London. She is also the author of *How to Draw the Human Figure: An Anatomical Approach*, also published by Penguin Books.

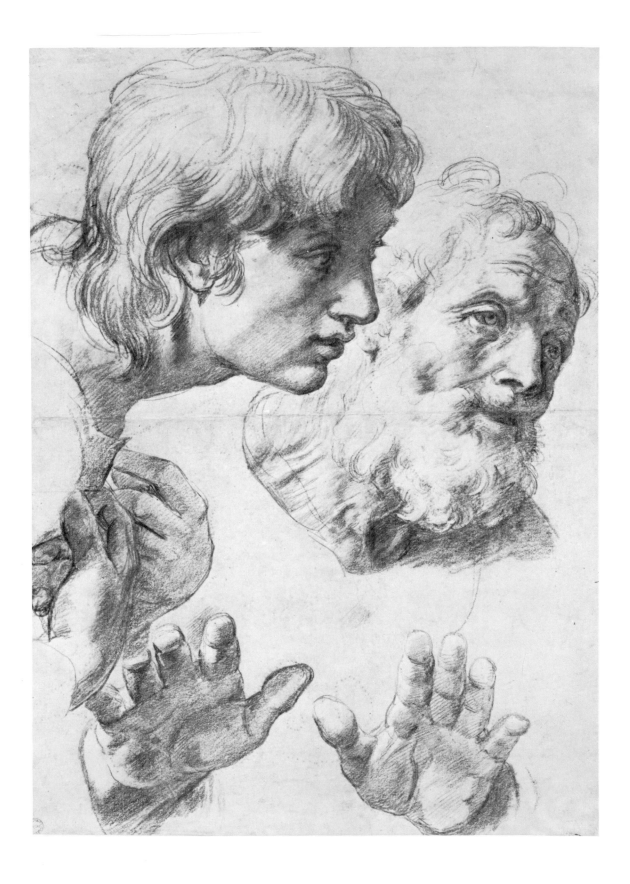

How to Draw the Human Head

Techniques and Anatomy

LOUISE GORDON

PENGUIN BOOKS

PENGUIN BOOKS
Published by the Penguin Group
Viking Penguin, a division of Penguin Books USA Inc.,
375 Hudson Street, New York, New York 10014, U.S.A.
Penguin Books Ltd, 27 Wrights Lane,
London W8 5TZ, England
Penguin Books Australia Ltd, Ringwood,
Victoria, Australia
Penguin Books Canada Ltd, 2801 John Street,
Markham, Ontario, Canada L3R 1B4
Penguin Books (N.Z.) Ltd, 182-190 Wairau Road,
Auckland 10, New Zealand

Penguin Books Ltd, Registered Offices:
Harmondsworth, Middlesex, England

First published in the United States of America by
The Viking Press (A Studio Book) 1977
Published in Penguin Books 1983

15 14 13 12 11 10 9 8 7 6

Frontispiece: Study for the Transfiguration by Raphael,
Ashmolean Museum, Oxford

Printed in Great Britain

Contents

The book

Although without detailed study of the anatomy of the head it is possible to draw an adequate likeness, an understanding of the bone structure and of the working of the muscles develops the quality of the work.

This book is for all those interested in drawing the head or in gaining further knowledge for their own particular needs in art, which includes that group working in portraiture. The material is by no means limited to portrait views, but encompasses pertinent information needed for creative positioning of the head to enable the artist to work with confidence from any angle he desires. In this it is of value to painters, sculptors, illustrators and those doing full figure work.

For the beginner, steps are given on how to start to draw the head, and what to look for in lighting and structuring so he will approach it as a unit. For the advanced artist, there is a wealth of detailed information. The anatomical knowledge is presented as an integrated part of what one sees, both in structure and in movement. The skull, muscles and movements are discussed and shown in detail. Particular attention is given to eye structure and the other features of the face.

The book is orientated towards the three-dimensional form of the head and how that form is interpreted on a flat surface. The methods of creating tonal areas to express that form are shown. Lighting, perspective, and the development of outline drawing are included.

The drawings throughout the book incorporate different technical approaches to give the artist ideas with which to experiment and develop his own personal expression.

The author

Louise Gordon AOCA, BA, DIP.MED.ILLUSTRATION, Canadian Academy of Medical Illustrators, is a graduate of Toronto Teachers' College, of Queen's University, Kingston, Ontario, and of the University of Toronto where she qualified in the three year course of Art as Applied to Medicine. She was lecturer and staff artist at the University of Toronto for eight years, and in addition was staff artist at Sunnybrook Veterans' Hospital.

For some years she worked as a free lance artist on some of the leading medical text books in Anatomy, Surgery and Histology.

In 1962 she was offered the position of Associate Professor and Director of the Department of Art as Applied to Medicine but preferred to expand her activities by developing her interests in sculpturing and painting. At the Ontario College of Art, she was awarded the Rowney, London, England, prize in painting, the Toronto Art Gallery Scholarship in Sculpturing, and on her graduation in 1965, the Proficiency Medal in Sculpturing.

Louise Gordon is a free lance artist and part-time teacher. Until recently she taught Anatomy and Life Drawing at the Sir John Cass College of Art, London.

Preface

This book is a natural evolution from the inspiration given to me by students, combined with my own experience in the Fine Arts and in medical illustration. Students, with their desire to draw, their different needs and the questions which come from enquiring minds, have helped me organize the material. A teacher should be a launching pad, and this book is hopefully just that. Drawing entails exploration, risk, discipline, and the ability to feel ridiculously inadequate without losing the will to soar. It has elements of the absurd and whimsical which ought not to be underrated; neither should intuition.

I have tried to integrate the anatomical knowledge with the forms one sees, so that the knowing and the seeing will have more unity. There are those who feel that spontaneity of passion and emotion can be inhibited by intellectual controls, but it has been my experience that a knowledge of anatomy coupled with technical discipline liberates rather than confines freedom of expression. With perseverance, co-ordination becomes less conscious which is part of the pattern of natural development in moving from unknowns to knowns.

Many ways have been used throughout the ages to depict what has been felt and seen in another's face. Drawing is probably the most personal.

The accompanying text is kept to a minimum in the belief that most artists are people who visualize. The drawings are orientated to the understanding of forms and the means of expressing them. It is hoped this will be of advantage also to the painter and sculptor. Much outline work which is especially necessary in commercial art is derived from interpreting forms in a linear way and examples are included. There are suggestions for those beginning, on how to start to draw a head and what to practise in order to develop confidence with a pencil. One of the greatest hurdles for those just learning is making the leap from the rigid silhouette line, to enjoying freely the experience of developing the many forms of the face. It takes courage and an open mind to try, but it is well worth it.

No standard rules are included for those average heads which don't exist. Every head is unique and its position so variable that one can only look at it each time as a new challenge. Methods for making specific relative measurements for the head which is being drawn are given and these are applicable across the broad range of age, sex, and race. Some of the views of the head encompass the needs of artists who work from

photographs. Medical names are necessarily used but where possible, explanations are given when they are descriptive of the place, shape or function of the structure.

Acknowledgment

My thanks are extended to the publishers and especially to Thelma M Nye, and also to Betty Maxey and Andrew Cooper for their most generous help and encouragement. I would also like to express my gratitude to five teachers: Elwood O Simpson, Maria T Wishart who started the Art as Applied to Medicine course in Canada and encouraged me as a student and friend, Dr J C B Grant, Professor of Anatomy and Dr A W Ham, Professor of Histology with whom I was fortunate to be a student in their courses at the University of Toronto, and Fred Hagan, Ontario College of Art.

I would also like to thank the Directors of the Ashmolean Museum, Oxford, for their permission to include the Study for the Transfiguration by Raphael which appears as the frontispiece to this book; the Directors of the British Museum, London, for the portrait of Elizabeth Brant by Rubens on page 32. The portrait of Archbishop Wareham by Holbein is reproduced by gracious permission of Her Majesty the Queen.

Louise Gordon
Putney 1977

The head and neck as a whole

An understanding of the skull which creates the basic forms of the head and provides many surface landmarks with which to structure, the muscles which give the movement, expression and superficial forms, the features which infuse the whole with aliveness, can add immeasurably to an artist's interpretation not only because of facts but because of the appreciation it brings of another human being, and of himself.

The skull

The bones are living substance, supplied with nerves and blood vessels, reactive to the conditions within the whole body, and capable of repair.

In the embryo the bones of the skull are preformed, by cartilage and membrane, in a soft phantom of what will be. The general form of one's skull is determined by the third month. It is in the pliable phantom that mineral salts are deposited and a binding medium called cement substance is formed to start to create the hard bone which we know. This process is called ossification. It continues during the nine month period in the uterus when the growth is very rapid. But when a child is born the bones of the skull and neck are by no means complete. The process of enlargement goes on, and the ossification is usually not totally completed until the adult reaches twenty-five years of age. In the early years between one and seven, and especially in the first year, there are noticeable changes of which the artist should be aware. The upper and lower jaws are increasing in size and changing form. They are becoming more prominent as they grow towards the adult state. The cranium, that part of the skull which encloses the brain and protects it, is enlarging as the brain grows. The margins of the bone of the orbital cavities in which the eyes sit are changing from being round in the baby to becoming more rectangular. It is the time of change from the rounder-eyed look of the baby to the longer-eyed look of the adult. Growth is slow from the seventh year until puberty. Then there is enlargement again, particularly in the face when the permanent teeth begin to form. This is when the lengthening of the face is noticeable and the distance from the eyes to the bottom of the chin becomes so much greater.

The bones of the cranium forming the housing for the brain are complex curved thin plates, eventually locking rigidly together when they are completely ossified, the joining edges meeting like those in a jigsaw

puzzle. The bones of the face come to be interlocked in exactly the same way; except the jaw. It is the only separate bone of the skull and provides the only movable joint in the head. This joint is in front of the ear where the rounded process, called the head of the jaw, fits into a socket provided by the temporal bone.

The bones of the neck are called the cervical vertebrae. There are seven of them placed on top of each other and separated by cushions called cervical discs. The vertebrae, like the skull, are not completely ossified until the twenty-fifth year. The discs are composed of tough fibres on the outside and a fibrous-gelatinous pulp filling. They act as shock absorbers. The column which the seven cervical vertebrae and their discs make is curved. And it is curved forward. It starts to form this way when the baby begins to raise its head. This is a most important point for the artist as the pronounced forward thrust of the whole neck should not be missed. It carries the head forward and upward. It is the vertebrae which set the angle and that angle reads through into all the soft tissues of the neck. Each vertebrae has a body, a little block of bone which bears the weight of the head and an arch to the back which creates a hole or canal. It is through these canals that the spinal cord runs, protected by the body and the arch of bone around it. From the sides of the arch there are projections of bone called transverse processes, one on each side. From the back of the arch there is a single projection of bone called the spine of the vertebra. These processes provide attachment places for the muscles to pull on the vertebrae so the neck can have its great variety of movements. The first cervical vertebra is fitted against the skull in such a way that we can get the 'yes' movement. The second vertebra fits into the first in such a way that we can get the 'no' movement from side to side.

The bones of the cranium

The FRONTAL bone forms the complete forehead as well as the upper part of the orbital cavity or 'cone of bone' in which the eye and its related structures lie. The bone of this upper margin of the cone can be felt under the eyebrow and is responsible for much of the form there. At the medial end of this margin the bone is thickened and is then called the superciliary arch. This arch is usually heavier and more prominent in the male than in the female. It can create an overhanging brow, or beetlebrow, particularly if the eyebrows are thick also. In the forehead the frontal bone has rounded contours, or eminences, on each side of the mid-line. These vary greatly in prominence in individuals. Look for them as they can catch light in a special way. The bone has four main plane changes which set the three-dimensional interpretation of the head in this area. The front plane which is the front of the forehead meets the top plane, which is the top of the head. The front plane also meets the right and left side planes of the forehead.

The PARIETAL bones are curved plates which form part of the top and sides of the cranium. They too have eminences, above and behind the ears. You can feel these bulges of bone on your own head. This is the widest part of the cranium.

The OCCIPITAL bone forms the lower part and back of the cranium. To it, particularly to its superior nuchal line which is a roughened line of bone across the back of the cranium, the important neck muscles are attached. It has a large opening underneath through which the brain becomes continuous with the spinal cord which descends in the vertebral canal. The first cervical vertebra, the atlas, articulates with the cranium on either side of this opening. It is called the atlas because in a symbolic sense it is holding up the world. The bone is called the occipital because it encloses and protects the occipital lobes of the brain which are concerned with sight.

The TEMPORAL bones form the lower sides of the cranium and it is from them our word 'temples' is derived. Their contribution to the cheek-bone is a small strong bar of bone on each side, running horizontally forward from the ear. You can feel this and see the form of it. It is called the zygomatic process of the temporal bone. Just behind the ears one can feel

lumps or projections of bone which are called the mastoid processes of the temporal bones. They are caused by the pull of the strong sterno-mastoid muscles on the bone of the cranium, as we develop. They do not begin to form until the second year. The absence of them makes a different form to look for behind the ears in the drawing of babies. The opening for the ear, the external auditory meatus, is a hole in the bone just in front and above the mastoid process. This is worth noting as the placement of the ear is controlled by its position. The temporal bone provides the little socket for the head of the jaw just in front of the external auditory meatus.

The bones of the face

The MAXILLAE form the upper jaw. If it protrudes the upper teeth will show more prominently and the upper lip will be thrust out. The lower margins of the orbital cavities are also part of the maxillae and are important landmarks. It is above this rim that the hollows or sacs under the eyes are formed and there is a plane change here, where the bone stops and the softer tissue around the eye begins. You should feel all around this margin for the orbital cavity on your own face. It is responsible for many of the subtle forms in this area.

The NASAL bones are small and join the frontal bones and the maxillae. They create the form of the upper part of the nose. You can feel where they end and where the cartilage begins. It is in this area that there may be a bump apparent and an extra wideness of the nose.

The ZYGOMATIC bones complete the cheek-bones with the zygomatic processes of the temporal bones. Together they are called the zygomatic arches which are important landmarks. You can feel the under edge running from in front of the ear into the cheek. In old age and in thinner people, the zygomatic bones create prominent forms on the face. Remember when you are drawing to match the two sides. It is in these bones too, that a plane change occurs from front to side. You can feel that corner and the change on your own cheek.

The MANDIBLE or JAW develops in two halves which fuse in the second year. It is horse-shoe shaped and carries the lower teeth. At the sides, the flat vertical area which has the angle is called the ramus. The front part is called the body. The ramus has two processes, the coronoid and the head of the jaw. The coronoid is a traction process caused by the pull of the temporalis tendon, and the head makes a joint with the temporal bone. The jaw has a great variety of sizes and forms. At the angle the bone often flairs out in the male and turns inwards in the female. This can give the 'stronger' jaw appearance in the male, as the whole jaw is usually larger also.

The bone structure of the face

The features are indicated to show the relationships of the bones to them. Note particularly the margins of the orbital cavity

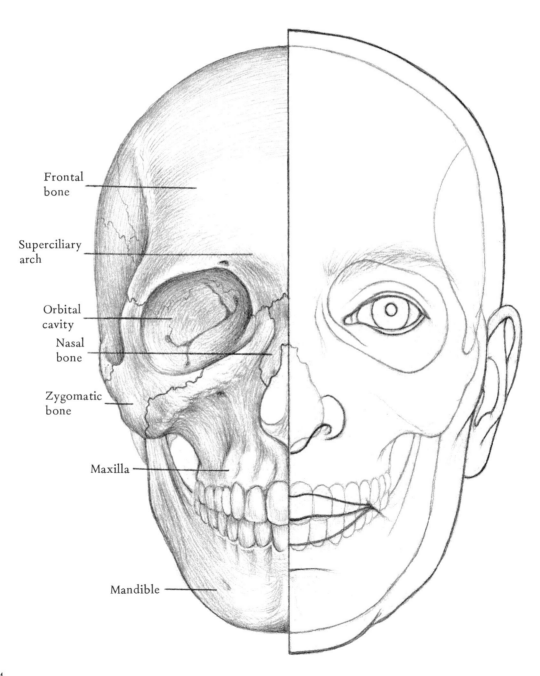

Frontal
bone

Superciliary
arch

Orbital
cavity

Nasal
bone

Zygomatic
bone

Maxilla

Mandible

The bones of the skull from the side

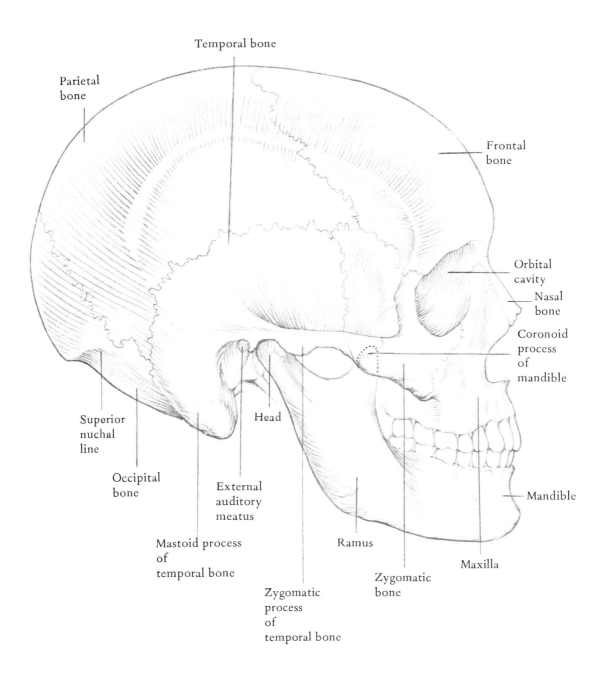

Temporal bone

Parietal bone

Frontal bone

Orbital cavity

Nasal bone

Coronoid process of mandible

Superior nuchal line

Head

Occipital bone

External auditory meatus

Mandible

Mastoid process of temporal bone

Ramus

Maxilla

Zygomatic process of temporal bone

Zygomatic bone

The muscles and their tendons

Muscles

Those cells of our body called muscle cells are specialized to perform one function only. That function is contraction. Muscle cells are long compared to other cells of the body, some being up to 40 mm ($1\frac{1}{2}$ in.) in length. Nature made them long instead of round so they can become shorter in length. It is the shortening of muscle cells by their ability to contract which makes movement possible.

Muscle cells contain in their protoplasm tiny fibre-like structures called myofilaments (*myo*, Greek for muscle). It is thought that these filaments have charged sites along their lengths which make a potential attraction between them. When a nervous impulse is received, one myofilament slides along and lies against another to which it is attracted. This process of 'doubling up' occurs throughout the protoplasm. It can shorten the cell by approximately half. Thus a whole muscle which is composed of masses of these cells can shorten by approximately half. It is this principle in action which creates movement in the body.

An individual muscle cell is enclosed in a loose connective tissue which is a combination of fibres and cells imbedded in a jellylike substance. These muscle cells line up together into bundles, also surrounded by connective tissue. A group of the bundles form one muscle, which is again surrounded by a sheath of connective tissue. The fibres of the connective tissue are protein and the jellylike substance in which they are imbedded is carbohydrate. It is the continuation of the fibres into bone which links them together and makes the attachment. They also can link muscle to muscle, or muscle to skin.

When a muscle contracts one end remains stationary while the bone, muscle or skin to which the other end is attached is pulled toward the fixed point. Muscles must be attached at both ends to produce movement.

Muscles take different forms depending on how their bundles are arranged. The quadrilateral, straplike and spindle-shaped ones have parallel bundles. The bipennate (feather arrangement), unipennate, and multipennate have their bundles arranged diagonally. The circular muscles have their bundles arranged in circles or ellipses around an opening. When that plan exists the muscle is called a sphincter. In your eyes it is the sphincter muscle in the iris which contracts to make the pupil smaller. That is the work of the circular type of muscle. It is capable, when its cells

shorten, of closing or closing down to some degree an opening. Three big muscles in the face, one around the mouth and one around each eye and incorporated in the eyelids are this type of muscle also.

All the cells in one muscle do not have to contract at one time. If the work demanded of it is only for a slight movement, a smaller number of cells will perform. If the work demanded of it is for maximum movement most of the cells will be contracting. But a cell cannot just partially contract. It is geared to the 'all or nothing law'. When it receives the nervous impulse it must shorten as much as it is able. There are just fewer cells functioning when the demand is for slighter movement.

This is rather a long explanation to include, though it is enormously simplified from the medical viewpoint, but I feel that it explains so much of what is seen in muscle movement that it could prove of value. It reveals why muscles bulge when a movement occurs in some particular part of the body. It also shows why there can be that slow change of form which we see on the surface as a movement is taking place. More and more bundles are coming into action until the muscle reaches its full capacity of work, if that is the demand on it. It explains too why a muscle appears to have one form on one occasion, and another form on another occasion. It all depends on how much of it is working. We draw the face in a static pose, the caught moment, but within it is this constant potential of rhythmic change which should never be forgotten. It also helps one understand the fleeting look, the half-smile, the half-grin and how so many of these subtle expressions in the face are possible.

Tendons

Tendons are usually round and cord-like or flat and band-like and it is these two forms we see on the surface. They are nature's method of attaching the 'movement-makers', the muscles, to various points so that action can be possible. A tendon does not contract. It is built for strength, consisting mainly of strong and tensile protein fibres, called collagen, arranged in parallel bundles. Normally they have almost no blood supply and the fibroblast cells lying between the bundles are dormant. The main fact for the artist to realize is that a tendon cannot change form in the way the working part of a muscle which has the muscle cells can change. It may change direction but the form is stable in remaining the same.

Aponeurosis

Where there is a very wide area of attachment needed, a tendon assumes a sheetlike form and it is then called an aponeurosis. We have this covering

the whole top of our craniums. It joins the sheet of muscle over our fore-heads to the sheet of muscle at the back of our craniums.

Cartilage

Cartilage, or gristle as it is commonly known, is a special kind of con-nective tissue with both collagen and elastic fibres imbedded in a firm gel. It is a substance with not only great tensile strength but it does not bend easily. It is a specific cartilage, called hyaline (*hyalos*, Greek for glass) cartilage which covers the head of the jaw and lines the socket and covers the joint surfaces of the vertebrae. Its surface is incredibly smooth and, with the lubrication of the fluid which is contained in joints, an almost frictionless action is possible.

The muscles and forms of the face

The ORBICULARIS OCULI is a wide, flat muscle which encircles the eye. It is a sphincter muscle. At the medial corner of the eye the encircling bundles are interrupted by the palpebral ligament which anchors that corner of the eye to the bone. You can roll that little ligament under your finger. It creates a tension point at the corner by keeping the lids pulled towards the nose. At the lateral corner of the eye the orbicularis oculi forms a raphe (the muscle bundles interweaving). The tightness caused by this raphe often creates a tucked-in look at that corner with an abrupt change of plane. The rest of the muscle bundles sweep right around the eye, the inner ones being within the eyelids and the outer ones lying over the bony margins of the orbital cavity and the bone beyond them. The upper bundles blend in with the frontalis and the corrugator but the lateral bundles are free. When the muscle contracts it closes the lids. When one squints, the free lateral part of it is pulled towards the nose. It is this action which causes the 'crows feet' wrinkles which become more pronounced as the muscle is used. Its encircling form below the eye is very important, and its movement reads through and causes encircling wrinkles in the overlying skin.

The FRONTALIS has no bone attachment. Its muscle bundles blend with those of orbicularis oculi at the eyebrow level and with the aponeurosis which covers the cranium on the top. It is a flat sheet of muscle with its bundles running vertically up over the forehead. The aponeurosis joins the occipital muscle at the back of the cranium. The frontalis, in contracting, pulls up the orbicularis oculi and the procerus. The eyebrows are raised and the form at the top of the nose is flattened. The skin of the forehead is thrown into horizontal folds.

The PROCERUS is a small muscle which is continuous with the frontalis and is attached where the nasal bones blend with the cartilage of the nose. Because this attachment is the stationary point, when it contracts it pulls down the medial part of the eyebrow area and causes horizontal wrinkles across the upper part of the nose.

The CORRUGATOR is a small cone-shaped muscle at the medial end of the eyebrow. It is attached to the frontal bone, at its medial end, and then

its muscle bundles pass laterally up through the frontalis muscle to reach and attach to the skin. When it contracts it pulls the skin and the eyebrow towards the nose. This causes a puckering in the skin above the eyebrow where little mounds appear. It is also responsible for the vertical creases in the forehead and those of the skin at the top of the nose. Skin is thrown into these folds or wrinkles because neither it nor the fat (if there is fat present) under the skin are contracting as much as the muscles lying under them. They increase more too with age and use as elasticity is lost in the skin.

The ORBICULARIS ORIS encircles the mouth primarily and it is therefore the sphincter of the mouth, but it also blends intimately with the muscles around the mouth which insert and weave into it. It extends up to the nose and down to the groove halfway between the lower lip and the bottom of the chin. It has a free edge within the lips and its work as a sphincter is to close the mouth. This it can do in three ways because it has three layers of muscle bundles which act differently. It can protrude the lips, it can pull them tightly together and it can also pull them tightly against the teeth. You can try these three actions yourself and see what different forms they cause around your mouth. The muscles of the face which radiate into the orbicularis oris are antagonistic to it, because they pull on it when they contract and therefore stretch it in many directions. When you are drawing the mouth, the fundamental encircling movement is the vital one to remember. The form above the top lip is especially richly curved as the strong curved form of that part of the maxillae is reading through the orbicularis oris and the skin in that area.

The LEVATOR LABII ALAEQUE NASI is a small muscle arising from part of the maxillae (the wing part – alaeque) close to the nasal bone. Its muscle bundles insert and blend with the orbicularis oris. When it contracts it lifts the lip, as its name says, and the skin on the side of the nose may be thrown into folds making the smiling wrinkles one often sees there.

The LEVATOR LABII arises from the front of the maxillae under the orbit for the eye and it inserts into and blends with, the orbicularis oris. It does what its name says, lifts the lip.

The ZYGOMATICUS MINOR and ZYGOMATICUS MAJOR both arise from the zygomatic bone. Their muscle bundles come forward diagonally in the side of the cheek and insert into the orbicularis oris near the corner of the

mouth. They both lift the corner of the mouth, drawing it to the side as well, and are called the smiling muscles.

The LEVATOR ANGULI ORIS arise from the maxillae and inserts into the orbicularis oris at the corner of the mouth. It does what its name says, lifts the angle or corner of the mouth.

All of the five muscles which insert into the orbicularis oris, when contracting, give the face the expressions of smiling or laughing. The corners of the mouth are pulled more widely and the upper lip is lifted. A smaller action of the ones which just lift the upper lip can produce the sneer. The skin and fat pad of the cheek become pouched out on top of the muscles which are shortening and a bigger bulk is built up in the cheek area. The overhang of the cheek onto the upper lip area is where they are inserting into the flatter circle of the orbicularis oris. Think of this part not as a line running from the nose to the mouth, but as two forms meeting with two planes resulting.

The RISORIUS arises from the tough capsular covering of the parotid gland which lies in front of the ear over the ramus of the jaw. The muscle is inserted into the orbicularis oris at the corner of the mouth. It runs almost horizontally across the side of the cheek and its stationary end is at the gland. When it contracts it pulls the corner of the mouth almost straight back to give the grinning expression, and it is often called the grinning muscle. While one of these muscles may predominate in its action, they all function together to a great degree.

The DEPRESSOR LABII and the DEPRESSOR ANGULI ORIS have their origins from the lower margin of the bone of the jaw and they insert into the orbicularis oris in the area below the lower lip. They pull down the corner of the mouth and the lower lip, as their names say. The two Labii meet in the mid-line and weave together under the lower lip. This contributes to the tucked in form in that part of the chin which often does not catch much light. The muscles together create rather flat forms on the sides of the chin which make definite plane changes.

The MENTALES are two cone-shaped muscles arising from the jaw mid-way between the lower lip and the bottom of the chin. You can feel the attachment inside your lower lip. The large ends of the cones are inserted into the skin of the chin. The mentales raise the lower lip and pucker the skin on the chin expressing doubt or disapproval. They sometimes appear

as two small mounds on the front of the chin and if there is a dimple, it is because there is a tiny cleft between the two cones.

The BUCCINATOR is a flat muscle on the side of the cheek which blends rather broadly with the orbicularis oris at the corner of the mouth. Its upper and lower muscle bundles run horizontally while its middle muscle bundles cross over each other. It pulls on the corner of the mouth, and is stretched in the blowing action and contracted in the sucking action. It helps in chewing by keeping that part of the cheek pressed inwards which keeps the food between the teeth.

The MASSETER is a flat muscle which runs diagonally over the side of the jaw. It covers most of the ramus of the jaw and is attached to the lower border of it. Above, it is attached to the zygomatic arch by a flat tendon. It holds the lower jaw tightly against the upper one and is used in chewing. The muscle creates a rich curved form on the side of the face particularly where it is making its attachment to the lower jaw. The front border of it is often a visible form angling back from the point of the zygomatic bone to the jaw. This is a form too which gets accentuated with age.

The TEMPORALIS is fan-shaped, its fleshy part attaching to the temporal bone on the side of the cranium and its tendon passing under the zygomatic arch to the coronoid process of the jaw. It works with the masseter by pulling up the lower jaw with force against the upper one, as when the teeth are clenched.

The PAROTID GLAND produces saliva which is carried by a duct which runs through the cheek tissues with its opening inside at the level of the second upper molar tooth. It folds around the ramus of the jaw, lies partly on the surface of the masseter, and also lies between the Sternomastoid and the jaw. It is enclosed in a dense capsule to which the Risorius is attached. It contributes to the fullness of form over the ramus of the jaw.

Different expressions resulting
from different muscles
contracting

23

The muscles of the face from in front

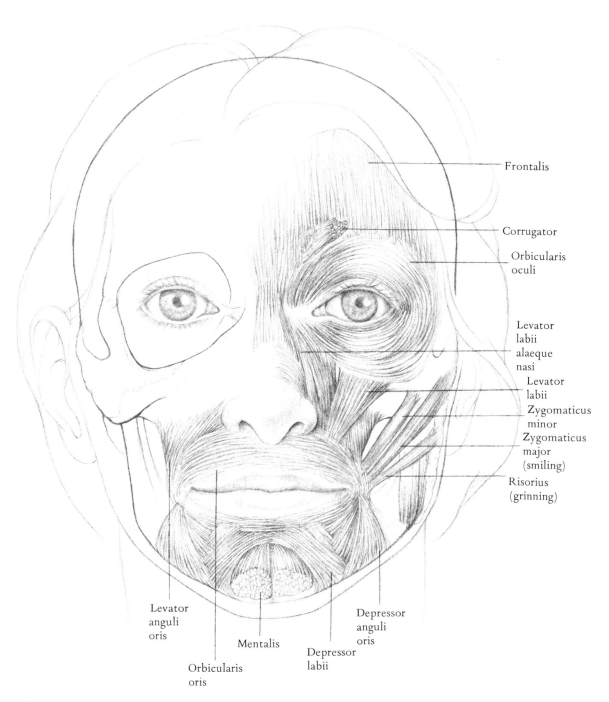

Frontalis

Corrugator

Orbicularis
oculi

Levator
labii
alaeque
nasi

Levator
labii

Zygomaticus
minor

Zygomaticus
major
(smiling)

Risorius
(grinning)

Levator
anguli
oris

Mentalis

Depressor
anguli
oris

Depressor
labii

Orbicularis
oris

The muscles of the face from the side

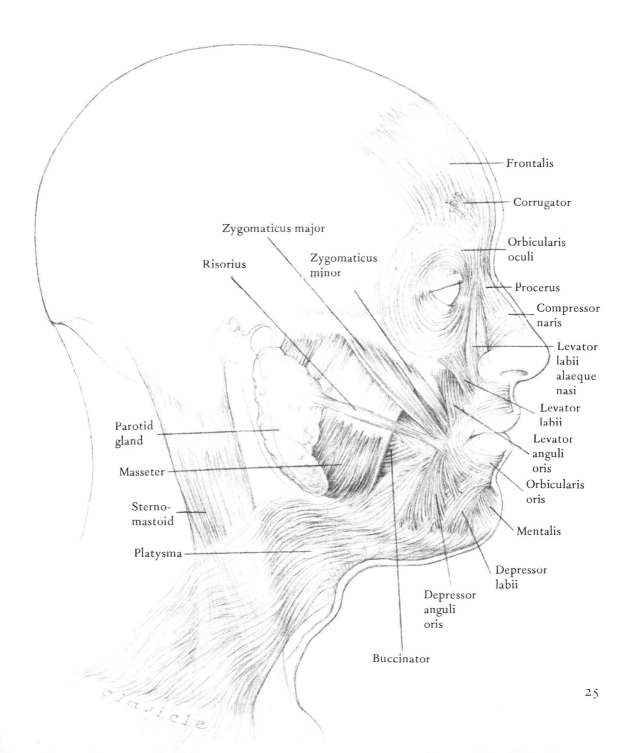

Frontalis

Corrugator

Orbicularis oculi

Procerus

Compressor naris

Levator labii alaeque nasi

Levator labii

Levator anguli oris

Orbicularis oris

Mentalis

Depressor labii

Depressor anguli oris

Buccinator

Platysma

Sterno-mastoid

Masseter

Parotid gland

Risorius

Zygomaticus major

Zygomaticus minor

clavicle

25

The muscles which give the expression of smiling, grinning and laughing

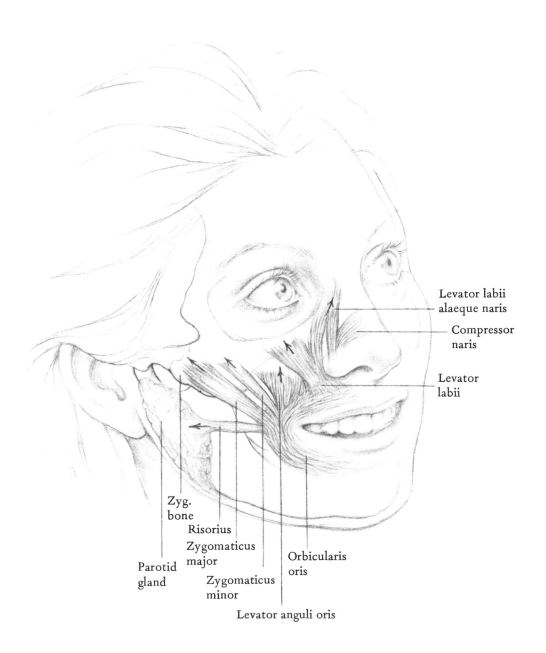

Levator labii
alaeque naris

Compressor
naris

Levator
labii

Zyg.
bone

Risorius

Zygomaticus
major

Orbicularis
oris

Parotid
gland

Zygomaticus
minor

Levator anguli oris

The actions of the temporalis and masseter

Note: In the usual 'rest' position of the face there is a space between the upper and lower teeth. The teeth meet only when these two muscles are contracting

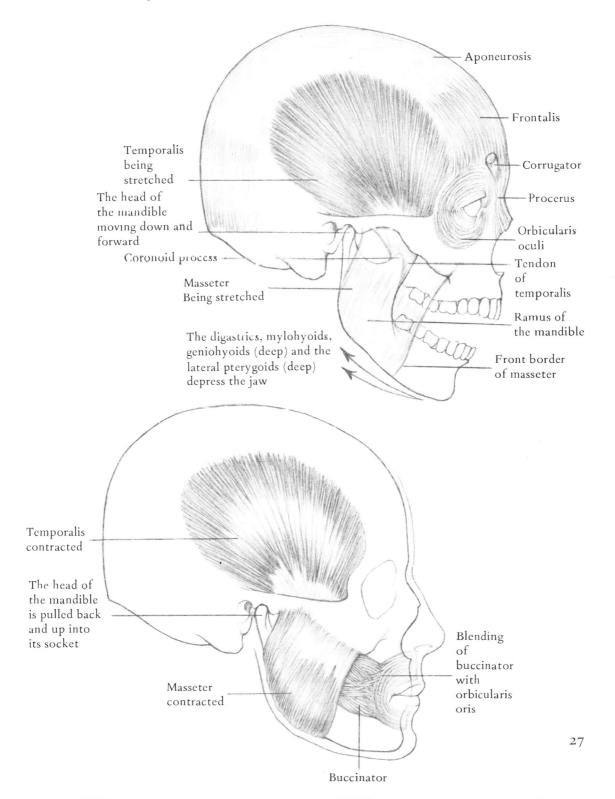

Aponeurosis

Frontalis

Corrugator

Procerus

Orbicularis oculi

Tendon of temporalis

Ramus of the mandible

Front border of masseter

Temporalis being stretched

The head of the mandible moving down and forward

Coronoid process

Masseter Being stretched

The digastrics, mylohyoids, geniohyoids (deep) and the lateral pterygoids (deep) depress the jaw

Temporalis contracted

The head of the mandible is pulled back and up into its socket

Masseter contracted

Blending of buccinator with orbicularis oris

Buccinator

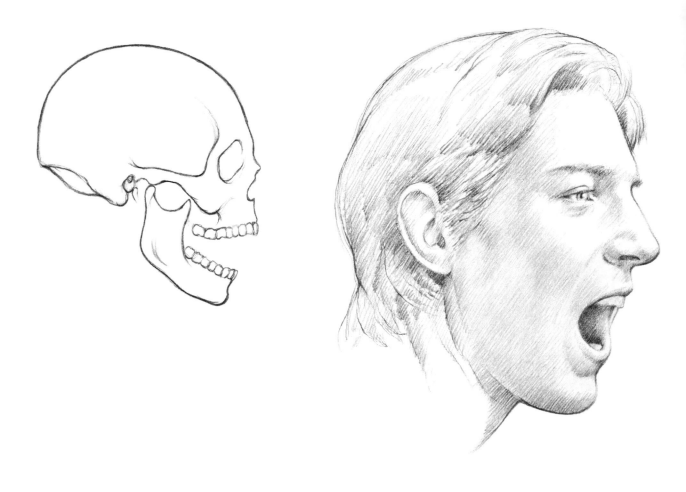

The jaw is opening downwards and backwards. The form of the head of the jaw is seen in front of the ear. The lighter toned form in front of it is the coronoid process, with the strong tendon of temporalis inserting into it, pressing out against the masseter. Both the masseter and the temporalis are being stretched

Different movements on the two sides of the face

As well as one side of the face being slightly different because development than the other side, one side can move differently than the other, as when one winks or draws just one side of the mouth up or down

In this example there is a grinning expression on the left hand side of the drawing due to the predominance of the risorius pulling back almost horizontally on the corner of the mouth. On the right hand side of the drawing the muscles lifting the upper lip and the angle of the mouth are all working to some degree, giving the smiling expression.

These two different movements make different forms on either side of the face. The grinning side is more 'at rest'. The forms of the cheek and under the eye are not quite as pouched as on the smiling side, where the muscle bundles are contracting more, the skin and fat on top of them is being crowded more so that even less of the iris of the eye is seen on that side

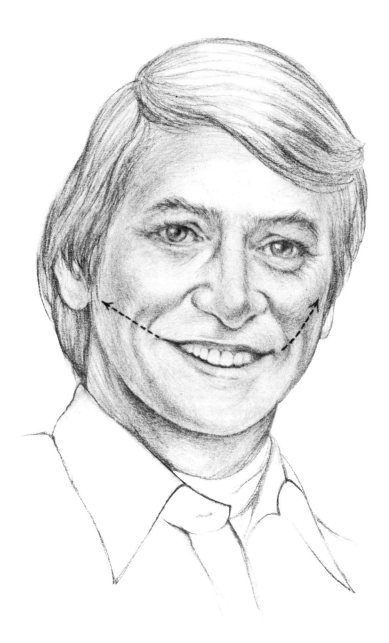

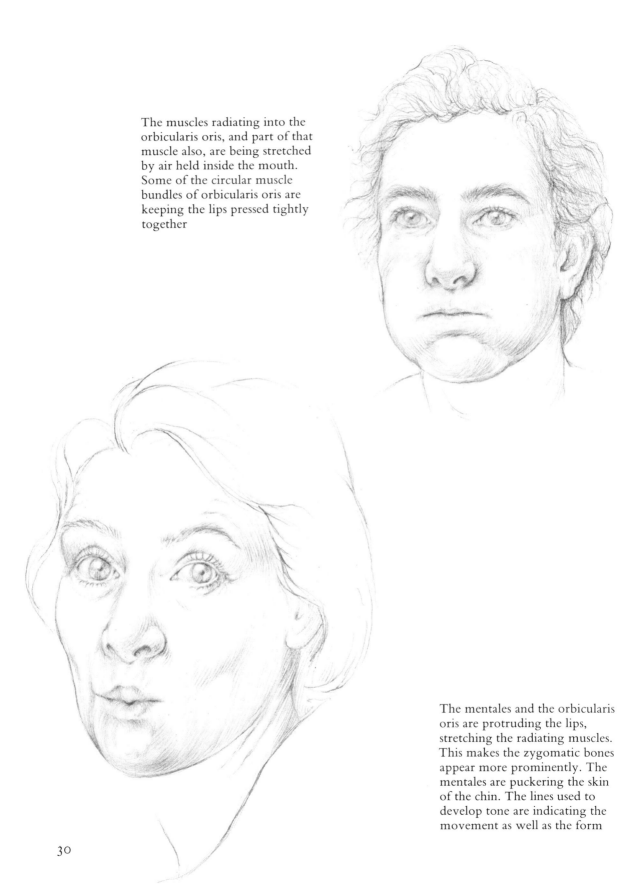

The muscles radiating into the orbicularis oris, and part of that muscle also, are being stretched by air held inside the mouth. Some of the circular muscle bundles of orbicularis oris are keeping the lips pressed tightly together

The mentales and the orbicularis oris are protruding the lips, stretching the radiating muscles. This makes the zygomatic bones appear more prominently. The mentales are puckering the skin of the chin. The lines used to develop tone are indicating the movement as well as the form

This drawing shows the corrugators working. The skin above the
eyebrows to which they are attached is being pulled medially
(towards the nose), which causes puckering. The soft tissue is
mounded over the superciliary arch area. Vertical folds are formed
at the top of the nose because of the crowding of the skin tissue
as the muscle bundles contract underneath it. The movement as
well as the form are shown by directional lines building up
towards the forehead area

Portrait of Elizabeth Brant by Rubens *The British Museum, London*

This vital drawing by Rubens shows the small movements and his
fine discrimination of forms to create a certain expression of the mouth.
The angle of the eyes also adds to the activity of the whole portrait.

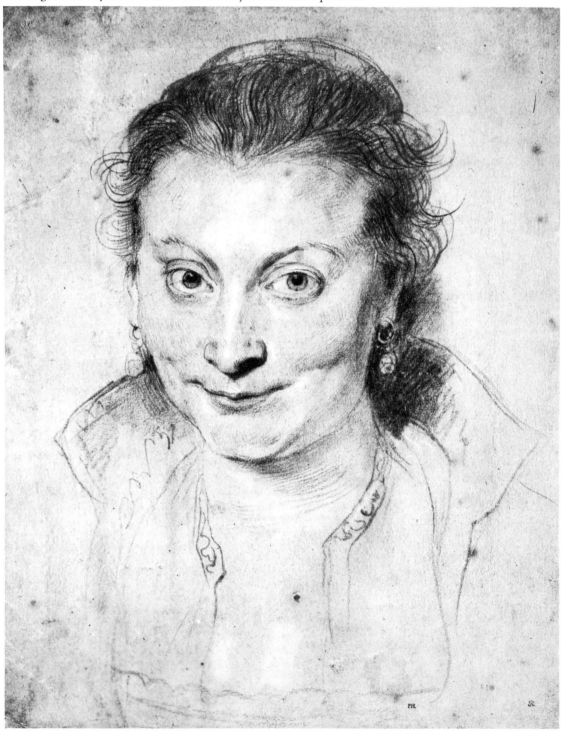

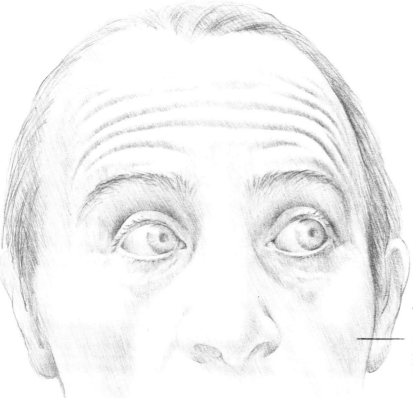

Direction
of
movement

Frontalis

Procerus

Raphe

Orbicularis oculi

This is the diagonal stroke
moving from the top left corner
to the bottom right corner, which
is the usual direction for the
left-handed artist

In this action of frontalis the eyebrows and soft tissues below them
(including the orbicularis oculi which is attached to the frontalis)
are being pulled up. The skin of the forehead is thrown into folds.
Remember these folds are definite structures, unique to each
person, and are three-dimensional forms to draw with sides and
tops. They are not just lines sprinkled at random above the
eyebrows. The procerus which is continuous with the frontalis
onto the nose is also pulled up, so it and the skin over it become
stretched and the whole form is flattened at the root of the nose.
There is a tautness at the outer corner of the eyes because of the
tightness of the raphe of the orbicularis oculi there. This makes
tiny extra forms which are part of the whole expression

Gravitational pull

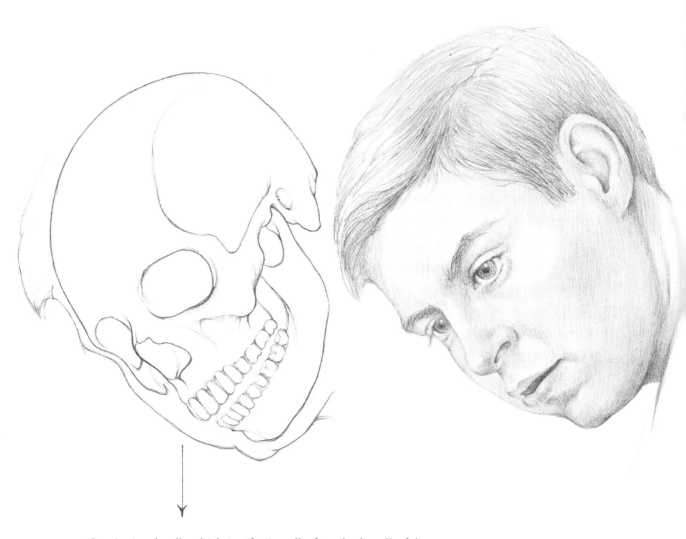

Gravitational pull, which is affecting all of our bodies all of the time, has an important effect on the soft tissues of the face. The hard tissue, the bone, though similarly affected is not flexible to move. The skin and fat layer under it are especially subject to this pull downwards. The muscles less so because they are more firmly anchored. This example shows the soft tissues, particularly in the lips and cheeks areas dropping earthwards from the rigid bone skeleton with different form than when the head is not tilted. This is part of the whole movement of the head and is an additive to the truth of telling the position of it. When a head is tilted sideways, the soft tissues fall 'off' one side (the lower side) and 'on' to the upper side. Look for this form change on yourself. It will be very slight in younger people, but as elasticity is lost due to ageing in the skin, these form changes become more and more important in the interpretation of a head. The mass of fat present in the tissues augments the form changes caused by this pull

The jaw

At birth the jaw is a relatively small form as are the maxillae which form the upper jaw. It is mainly these two facts which account for the different proportions between the baby's face and that of the adult. The size of the whole head at birth is of course less as the cranium is also smaller. The eyes, therefore, appear much lower in the face.

As a child develops the jaw elongates to make room for extra teeth and it also grows deeper. This process of growth goes on until it reaches adult size. The angle of the jaw with which one begins life remains the same until the teeth are lost. Then some of the bone of the jaw in the tooth-socket areas is absorbed. The jaw becomes smaller and the ramus with its angle becomes more diagonal.

The jaw is capable of several movements which you can try for yourself. It can be pulled down and up, forwards and backwards, and it can be waggled from side to side. The chewing movement incorporates these movements into a rotary one. Some people when speaking or singing do so out of the sides of their mouths. This motion is caused by the jaw swinging to one side or the other and often becomes a permanent expression of the face. The jaw can also be drawn to one side or the other because of the upper and lower teeth not meeting properly. When the mouth is opened very widely the articulating head of the jaw, though it is held very strongly in its socket in the temporal bone, rides forwards and downwards as it has a special disc attachment to the socket. It then comes to sit on a small eminence of the zygomatic process, in front of the socket. Look for this important change of form and the new position of the head. You can feel this action on yourself and the movement of the head.

When the jaw is a short one, the upper teeth and upper lip will protrude more. When it is a long one, in a profile view, the lips will either be in line or the lower lip will protrude. This observation does not hold with lips of the negroid race which are so much fuller form. Take note too of how the skin folds at the corners of the mouth. The lower lip very often appears to tuck under the upper one. This is usually when the upper lip is in front of the lower one.

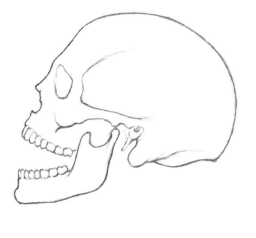

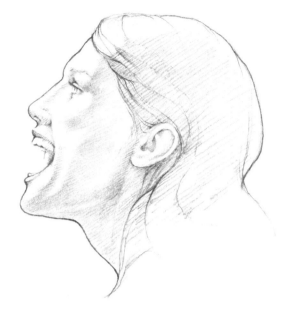

The head of the jaw has moved forward out of its socket and is
riding on the eminence of bone in front. The muscles of the face
are all being stretched as it is the muscles under the jaw which are
doing the work in opening it. The masseter form becomes flatter
and in this example the light is falling on the plane of the front
border of it, which is taut. The corner of the zygomatic bone is
more apparent as the skin becomes tightened over it

Each head is unique

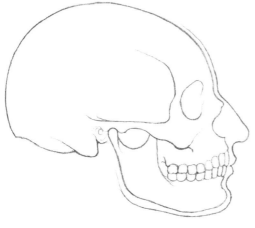

The average skull and corresponding features in a white man. The upper lip is projecting slightly beyond the lower one. The upper teeth are projecting beyond the lower ones. The forehead is rising fairly vertically

Compare the average skull and features in the diagram above, with the diagram and portrait below. This shows only a few of the factors which can contribute to the uniqueness of each head

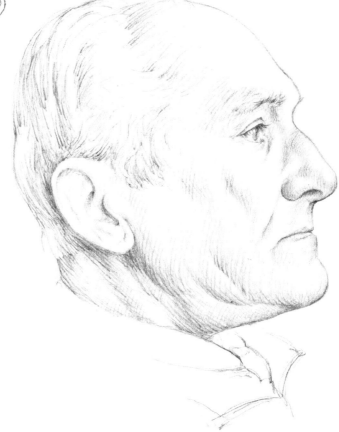

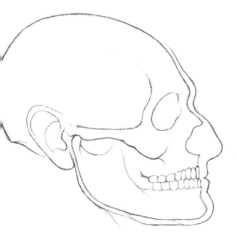

The frontal bone is receding, resulting in a sloping forehead. The nasal bones are longer and the bump form on the nose is slightly lower than usual. The main difference is the much larger and longer jaw, and the correspondingly longer zygomatic arch. This causes a much longer side on the face and sets the ear area back further. The lower teeth are projecting in front of the upper teeth and the lower lip beyond the upper lip. These are just some of the differences possible in a head and to be looked for. They are all dependent on the skull form

Side to side movement of the jaw

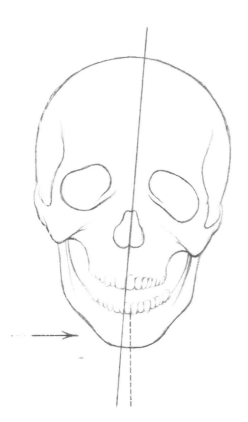 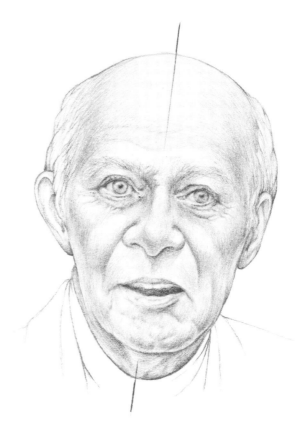

His jaw is swinging to his left side. The masseter of his right side is then stretched which flattens the form on that side. The mentales (with the orbicularis oris) are protruding the lower lip and causing the puckering in his chin

The nose

The framework of the nose is composed of bone, cartilage, and the fibrous-fatty material which forms the nostrils. The nasal cavities are separated by a partition which is held firm because it has a wall of cartilage in it, the septal cartilage. This partition is usually deflected to one side, so that one nostril opening is a different size and shape than the other. Look for this when you are drawing the nose from below. The two nasal bones, with contributions from the frontal bone and the maxillae are the bony part of the nose. There are two upper nasal cartilages firmly attached to it and they are continuous with the septal cartilage. They form the middle part of the nose. There can be a very definite change of plane, particularly noticeable in profile view, where these upper cartilages attach to the bone. There can also be a widening of form in this area. Examine your own nose and feel for this juncture. Two lower cartilages are responsible for the wide variations of form on the end of the nose, from bulbs to beaks. The form may appear as a unit or have a cleft in it which is caused by a slight separation between the two cartilages, at the tip. You can feel these two cartilages on the end of your own nose

Help in drawing the nose
1 Look for the four parts; bony, upper and lower cartilages and the nostrils
2 Look at the nostrils and see what their relationship is with the eyes, by sighting along a vertical line between the two. If you need a light guide line, put it in.
3 For those starting to draw, it helps to begin by building form around the tip, then the nostrils, and then assess the top plane and two side planes which the nose has. This method protects you from putting two little lines down either side of the nose and two black holes for nostrils.

The structure and form of the nose

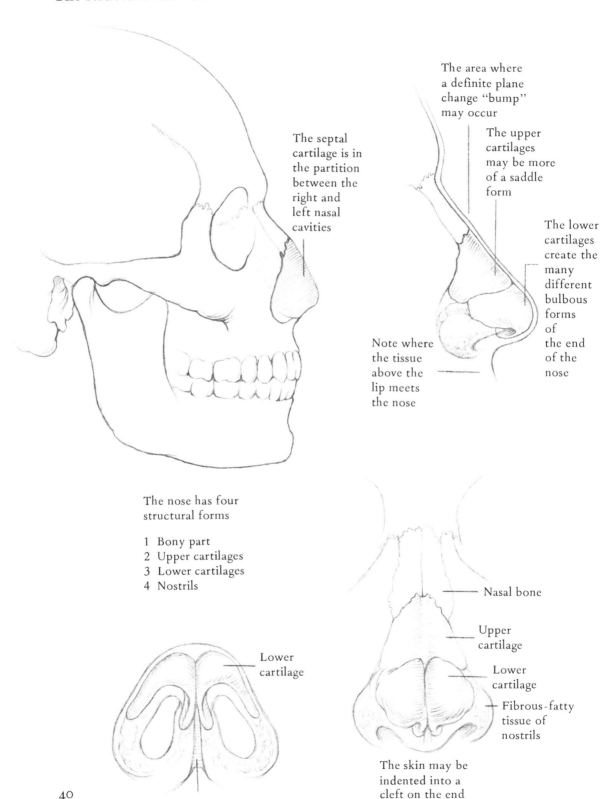

The septal cartilage is in the partition between the right and left nasal cavities

The area where a definite plane change "bump" may occur

The upper cartilages may be more of a saddle form

The lower cartilages create the many different bulbous forms of the end of the nose

Note where the tissue above the lip meets the nose

The nose has four structural forms

1 Bony part
2 Upper cartilages
3 Lower cartilages
4 Nostrils

Lower cartilage

The septal cartilage

The nose structure from below

Nasal bone

Upper cartilage

Lower cartilage

Fibrous-fatty tissue of nostrils

The skin may be indented into a cleft on the end of the nose when the lower cartilages do not meet closely

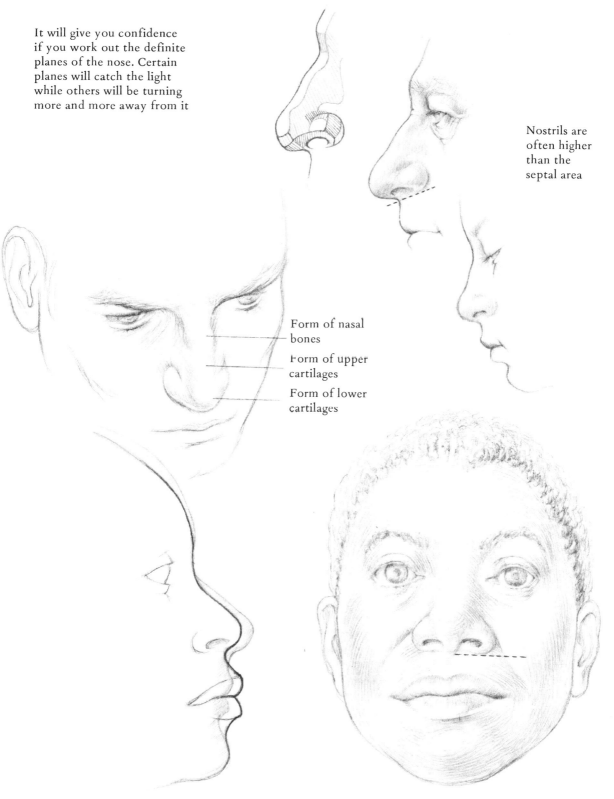

It will give you confidence
if you work out the definite
planes of the nose. Certain
planes will catch the light
while others will be turning
more and more away from it

Nostrils are
often higher
than the
septal area

Form of nasal
bones

Form of upper
cartilages

Form of lower
cartilages

The Negroid nose is flatter and the nostril area
is wider than in the white race

The lips

So many have asked me why the upper lip has its particular form that these two diagrams are included for explanation. The central part of the upper lip and the nose develop from frontal-nasal processes. The sides of the upper lip develop from maxillary processes. These fuse about the eighth week

sixth week eighth week

The upper lip has three forms within it, and the bottom lip has two

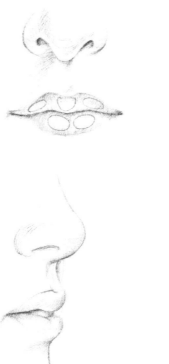

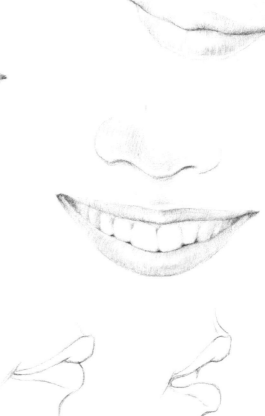

The change of plane on the side of the mouth and lips

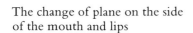

The ear

The framework of the ear is one piece of elastic cartilage except for the lobe which is made of the same fibrous–fatty tissue as the nostrils. This cartilage, covered with skin, is the form of the ear. It is continuous with the cartilage lining the external auditory meatus which leads to the middle and inner ear. The opening of this meatus (channel) is just behind the jaw-joint, as shown in the side view of the skull, and the ear is therefore structured around these landmarks. You can feel and see these relationships on yourself

If you take a little time to understand these few comments and examine the position of your own ears, you will have greater certainty in where the ears should be placed. In most cases of course the other features take precedence in interest over the ears, but if they are not placed and constructed sympathetically they can detract greatly from the integrity of a portrait

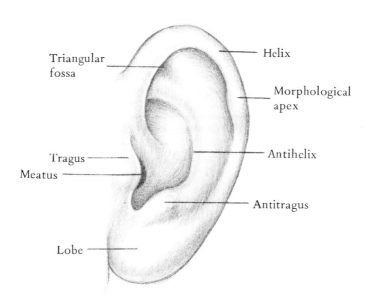

Triangular
fossa

Helix

Morphological
apex

Tragus

Meatus

Antihelix

Antitragus

Lobe

Look for the changing form
when the ear is in perspective

You can begin to place the ear
by relating it to the jaw, in
most views. It is usually tilted
slightly backwards as shown in
the example on the right. See
what the horizontal relationship
of the top of it is with the eye
area, and of its lobe with the
mouth area. Remember ears
differ greatly in size and form
from person to person. If you
can see both ears in your view
of the head, it helps to structure
them together

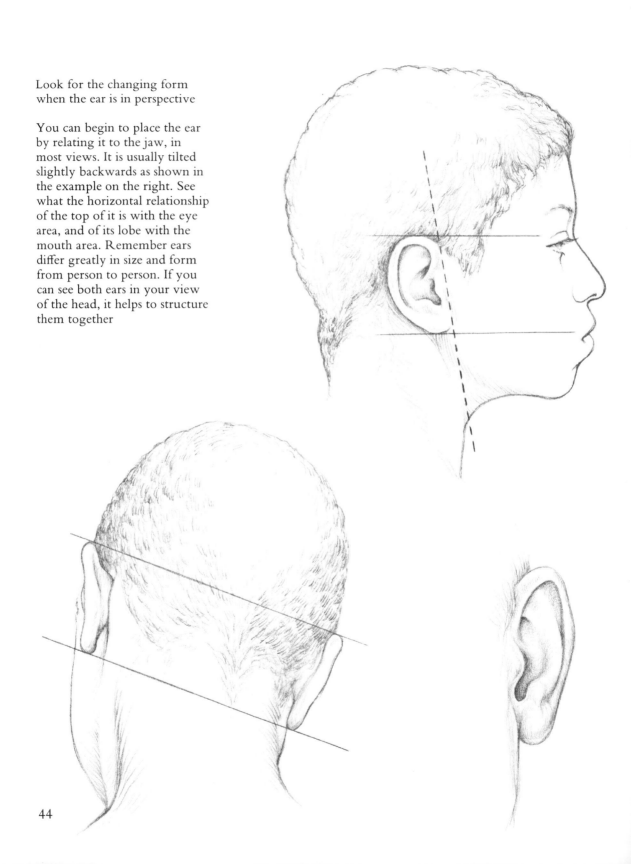

The eyes

The eyes have that special essence of something from within coming to the surface and being revealed there. This is a physical fact also. Other features of the face are projections from the surface, or are part of the surface. I deal with the eyes in detail hoping to evoke a special feeling for the dimensional drawing needed to express them. They are so vitally important.

The EYEBALL at the completion of its development lies protected behind its eyelids and within its cone of bone, the orbital cavity. This position places the eyes in the front of the face. I have seen many miracles performed by exploratory students but the greatest are eyes growing halfway to the ears or sliding up the sides of the nose. They are in their bony cones, on the frontal plane in the human.

The eyeball is about one inch in diameter, the white part called the sclera making up five-sixth of the ball. The front one-sixth, the transparent cornea, projects from this ball like a little dome. Behind the cornea is a flattish disc called the iris, with its different colours. The hole in it, called the pupil, allows light to pass through to the retina at the back of the ball. The iris has two kinds of muscle bundle arrangements in it: radially running ones which contract to open the pupil and circular ones which act like a sphincter to close the pupil. The lens is suspended behind the iris and pushes a little against it. There is fluid in the space behind the cornea and behind the lens. Because the cornea has a different form than the rest of the ball, light strikes it differently. The variation in the 'light shapes' you see on the eye are due to where the light is striking the form. The light penetrating the cornea can create luminosity in the fluid behind the cornea, showing up more structure in the iris.

The ORBITAL CAVITY contains the eyeball in its anterior half, the eyeball projecting a little beyond it, and is filled in its posterior half by the optic nerve (developed along with the retina from the forebrain), fat, the muscles which control eye movement and the vessels. The fat serves to cushion the eye if it is struck. In an emaciated person, with fat depletion, the eye will sink back into the orbit. The bony margin of the orbital cavity is more circular in a child than in an adult, in the female than in the male, in the yellow races than in the white, and in the white than in the black. Its

progression is to a rectangular shape, but the variation is great from person to person. The upper and lower bony margins rise diagonally towards the nose. The bone reads through into the soft tissues which lie over it, so that aspects of its form show.

The EYELIDS are composed of soft tissue which takes the form to a great extent of the eyeball under them. If you draw the eyelids with a feeling for the ball behind them you will get much richer form. I think the main thing to remember about the eyelids is that they have thickness. The lateral five-sixth of the lid edges are flat which shows this thickness clearly. It is especially apparent in the lower lid when one is looking directly at a person. The medial one-sixth of the lids has rounded form and no lashes. The upper lid forms a complete elliptical curve but the lower one has a straight part at its medial end. Both lids are in close contact with the eyeball and follow its curve. Look for the way the lower lid curves up to the lateral corner, and how it meets the upper lid there. The upper lid is capable of much greater movement.

The MUSCLES of the eyeball are concerned with the eight eye movements, and there are six of them: four oculi recti and two oculi oblique. They are attached to the eyeball and to the bone inside the cone.

GENERAL STRUCTURES: The medial canthus (corner) of the eye is usually lower than the lateral canthus, so that the eye is set in a diagonal which runs down towards the nose. This is to enable the film of tears which bathes the eye constantly to drain to the tear ducts which open into the upper and lower lids in that corner. The lacrimal gland producing the tears is under the upper lateral margin of the orbital cavity and its lacrimal ducts open into the upper lid, carrying the tears. In the medial canthus are two forms: a small reddish nodule called the caruncle, and a fold of conjunctiva called the plica semilunaris (half-moon). The space between the eyelids and the eyeballs is called the conjunctival sac. It is lined by conjunctival membrane and this plica is a fold of that membrane.

The eye

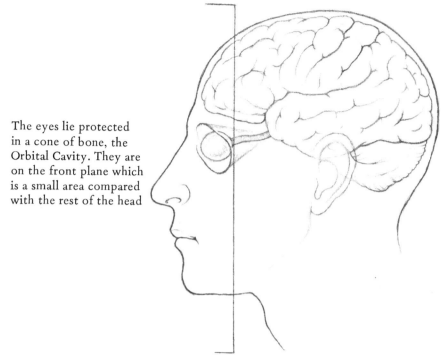

The eyes lie protected in a cone of bone, the Orbital Cavity. They are on the front plane which is a small area compared with the rest of the head

View from above

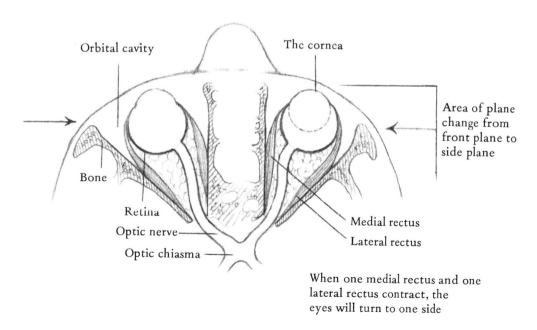

Orbital cavity

The cornea

Area of plane change from front plane to side plane

Bone

Retina

Optic nerve

Optic chiasma

Medial rectus

Lateral rectus

When one medial rectus and one lateral rectus contract, the eyes will turn to one side

47

The eyeball and related structures

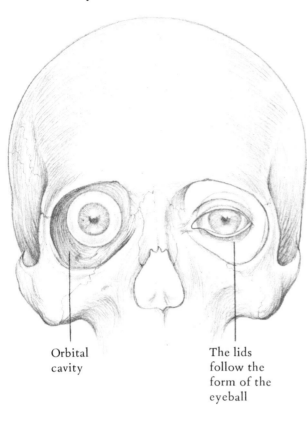

Orbital cavity

The lids follow the form of the eyeball

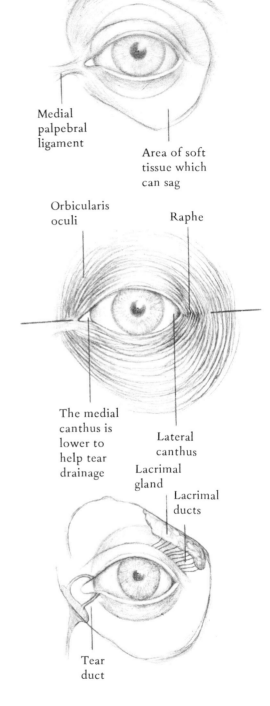

Medial palpebral ligament

Area of soft tissue which can sag

Orbicularis oculi

Raphe

The medial canthus is lower to help tear drainage

Lateral canthus

Lacrimal gland

Lacrimal ducts

Tear duct

Form of palpebral ligament

Form of orbital bone margin under eyebrow

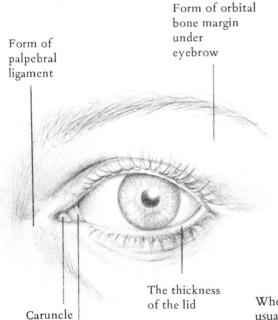

Caruncle

Plica semilunaris

The thickness of the lid

When the eye is looking forward in a natural position the upper lid usually crosses the iris halfway between the upper edge of the iris and the pupil. The lower lid just meets the lower edge of the iris

The eye from the side in section

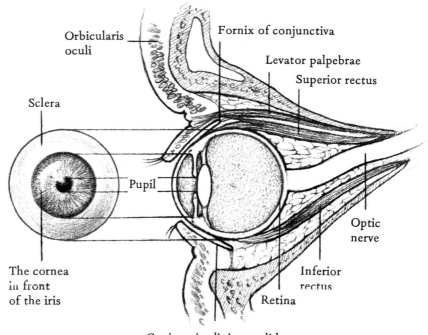

Orbicularis oculi

Fornix of conjunctiva

Levator palpebrae

Superior rectus

Sclera

Pupil

Optic nerve

The cornea
in front
of the iris

Inferior rectus

Retina

Conjunctiva lining eyelids
and reflecting onto eyeball
as far as the corneal margin

The components of the eyeball

The iris, though circular in front view, becomes elliptical (an oval)
in side view because it is disc-shaped

When the superior rectus rolls up the eye, the levator palpebrae
lifts the upper lid because they share the same nerve

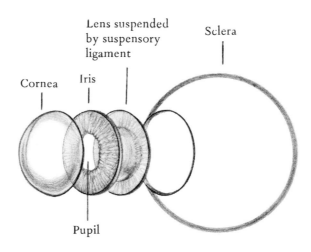

Lens suspended
by suspensory
ligament

Sclera

Cornea

Iris

Pupil

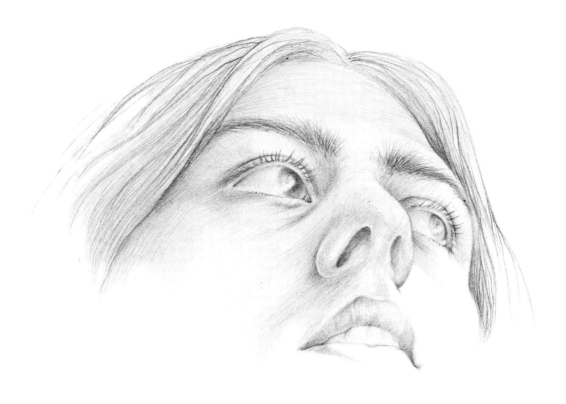

When viewing the eyes from below, the thickness of the upper
lid is very apparent. It takes the form of the eyeball with which it
is in such close contact. The thickness of the lower lid is lost to
view. When looking straight at a person, the thickness of the upper
lid, because it is covering more of the eye than the lower lid and
projects further out over the ball, catches light differently which
often causes a shadow being cast by the upper eyelid on the eyeball

The form of the eyeball

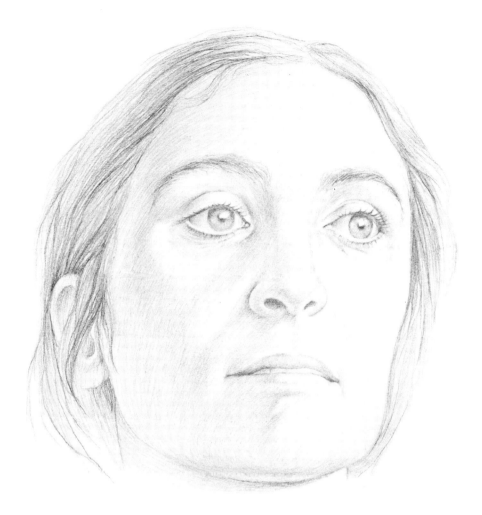

When the face is turned even slightly away from you, the far eye
will not be as long as the near eye because of the loss due to seeing
it in perspective. The far side of the face will not be as wide
either and this also applies to the far half of the nose and the far
half of the mouth. All are diminished slightly

The eyeballs, in being round solid objects, have form as an
orange has. There will be a part of the form on which light falls,
and part which turns away from the light source to be in shadow.
This means that the 'white' of the eye is often in a position which
needs tone on it. The light in this example is falling on the corneas
and the rest of the eyeball is getting less light

The irises, because they are discs, become slightly elliptical in
this view. In the direct front view the discs are circular, but the
more a face is turned away from you, the more elliptical the iris
becomes. Try this principle with a coin

Section through the head

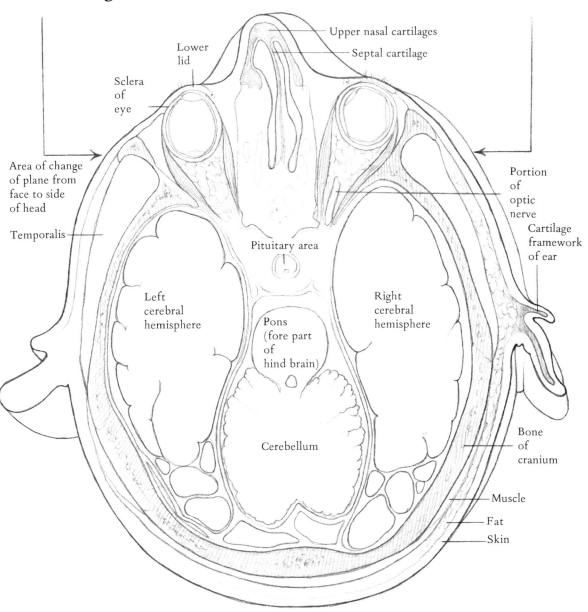

Upper nasal cartilages

Septal cartilage

Lower lid

Sclera of eye

Area of change of plane from face to side of head

Portion of optic nerve

Cartilage framework of ear

Temporalis

Pituitary area

Left cerebral hemisphere

Right cerebral hemisphere

Pons (fore part of hind brain)

Bone of cranium

Muscle

Fat

Skin

Cerebellum

This purely medical drawing is included to help you understand better the superb unity of the head and in particular to help you see that the eyes are protected and integrated forms in the total structure.

In a drawing which is expressing three-dimension, the change from the front plane of the face to the side plane of the head is important. This can be seen in this aspect. In a direct frontal view,

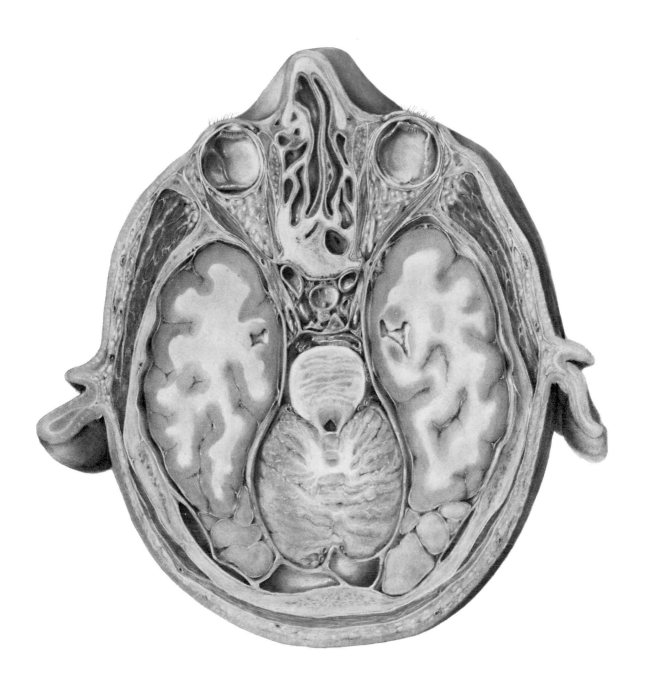

the width across the face is narrower than the width across the cranium. Both sides of the head will be visible and also the ears, which are placed in front of the widest part of the cranium.

I am including it also for those with curiosity, and I have found them to be many, who are interested in learning not only about the face but what lies behind the façade

The muscles and forms of the neck

The muscles of the neck can be divided into two groups: there are those which are attached to the hyoid bone and are concerned with the functions of swallowing, chewing, and using the voice, and there are those concerned with the bigger movements of the neck.

First group

This group of muscles attached to the hyoid bone and lying in the front of the neck are either arising from the lower margin of the jaw, which is the stationary point, and inserting into the hyoid bone, or they are arising from the sternum and clavicle, which are the stationary points, and inserting from below into the hyoid bone. It is this precise arrangement of muscle groups which allows the trachea (windpipe) and the adams apple (thyroid cartilage containing the vocal ligaments) to be pulled up, so that the air passage is blocked, or pulled down so that air can pass in and out. This unit comprised of the hyoid bone, the thyroid cartilage with the vocal ligaments attached inside it, the trachea with its rings of stiff cartilage to keep the tube open, makes the columnar form at the front of the neck, along with the muscles and ligaments which bind this unit together to allow it to function. If you place your fingers over your own thyroid cartilage, and swallow, you can feel it being pulled up which closes the air passage off into your lungs. Then the whole unit is pulled down by the balancing lower group of muscles, so that air can once more be taken in. It is very difficult to swallow when the jaw is loose and hanging open, because the firm stationary point is lost.

On some very thin and longer necks you will be able to see the hyoid bone causing a mound on the surface, the thyroid cartilage looking as though it is coming right out through the skin, the cricoid cartilage which is a complete and stiff ring below the thyroid cartilage, as a separate form, and the tubular form of the trachea, and sometimes the forms of its cartilaginous rings, before it descends behind the sternum towards the lungs. You can certainly see the form of the column as it angles back and down, because the trachea has to get inside the rib cage where it divides into the bronchi for the lungs.

The MYLOHYOIDS are a flat sheet which fill in the whole area under the chin. They arise from the margin of the jaw and insert on the hyoid bone.

The DIGASTRICS (meaning two stomachs or bellies) arise from the margin of the jaw in front, and finally insert into the mastoid process. There are two bellies on either side in the neck, joined by a middle tendon which is held down by a fibrous loop to the hyoid. One can sometimes see the form of the anterior belly as it runs backwards from the chin area, when the underneath part of the chin is in view.

With the geniohyoids which lie deep to the sheet of the mylohyoids, the digastrics depress the jaw by pulling down on the front margin, and so open it.

Muscles below the hyoid bone
The muscles capable of pulling down the hyoid bone and the unit, are four in number: thyrohyoid, sternothyroid, sternohyoid, and omohyoid.

The first three are strap muscles and their names tell their attachments, sterno referring to the sternum, or breast bone. The omohyoid has two bellies on either side like the digastric. The middle joining tendon is held by fibrous loops to the clavicle. The muscle is attached to the scapula (shoulder blade) and the hyoid.

You may see the strap form of these muscles and particularly the front borders, when the head is thrown back and the muscles are being stretched. They account for the build up of the rounded form of the column in the front of the neck.

Second group
The neck is considered to have an anterior and posterior triangle on either side, which may help you to understand the structures more clearly. There is an illustration showing these triangles. The anterior triangle has passing through it, the carotid arteries with blood for the head, the internal jugular vein returning the blood, as well as nerves. It is a receding form, a triangular dip in the side of the neck and therefore the light does not fall on it readily, so it is often in shadow. The posterior triangle has five muscles running diagonally through it, and when the neck is stretching to the 'away' side, these oblique forms can sometimes be seen.

The SPLENIUS (meaning bandage) is a muscle which wraps around the side of the neck. It arises from the Ligamentum Nuchae (described a little later) and from the spines of the first six thoracic vertebrae. It spirals up-wards, part of it attaching to the transverse processes of the first four cervical vertebrae, and part of it to the mastoid process of the temporal bone. It adds bulk to the back and side of the neck. When it contracts the head is

drawn to one side and rotated so the face is turned to that side. When this happens, the form will be much thicker. It is the top muscle in the posterior triangle.

The LEVATOR SCAPULAE arises from the transverse processes of the first four cervical vertebrae and it is inserted into the upper part of the medial border of the scapula. It lifts and stabilizes the scapula. It is the second diagonal muscle form which may be seen in the posterior triangle.

The THREE SCALENES fill the remainder of the posterior triangle. Their forms may be seen as diagonal bands running across the neck when it is stretched to the 'away' side. This is when the scalenes of the opposite side are working. The scalenus anterior arises from the transverse processes of cervical vertebrae 3, 4, 5, and 6 and is inserted into the first rib. The scalenus medius (the middle one) arises from the processes of 2, 3, 4, 5, and 6 cervical vertebrae and is inserted back further on the first rib. The scalenus posterior arises from the processes of 3, 4, and 5 cervical vertebrae and is inserted into the second rib. Their work is to bend the neck to the same side they are on, and they do this by pulling on the vertebrae.

The LIGAMENTUM NUCHAE is a continuation in the neck of ligaments which tie the vertebrae together. It is a tough, thin sheet of strong fibres, situated in the mid-line at the back of the neck. It is attached to the back of the cranium (the occipital bone) in the mid-line and the spines of the seven cervical vertebrae. Its free edge then spans between the cranium and the seventh cervical vertebra. It is to this sheet or thin wall that the splenius is attached in part. If the form dips in along a mid-line at the back of the neck it is due to the pull on the edge of this ligament. One sees this indentation often. There is an illustration which shows this ligament.

The STERNOMASTOID is probably the most important landmark in the neck for the artist because it has such prominent form which is always present. It arises by two attachments, from the sternum and from the clavicle, and these attachments are called the heads of the sternomastoid. The clavicular head is wide and flat, and the lateral edge of it is seen as a curved form when the sternomastoid is drawing the head to the same side, or as a straight form when the head is erect. The tendon of the sternal attachment is very apparent as it arises from the front of the sternum and the upper border and is seen as a rather sharp-edged band on the surface. There is a notch at the base of the neck formed by a dip in the manubrium

(the upper part of the sternum) and it is bounded on either side by the two sternal attachments. You can see and feel this notch in your own neck. It is called the suprasternal notch and is not only a very important landmark but of great help in making measurements, as it is a stationary point. The two heads blend together to form a thick mass of muscle, like a heavy strap, and then the form becomes flat again as it moves to insert into the mastoid process and into the superior nuchal line of the cranium. Look for these changes of form in the sternomastoid. The thick part in the centre has the muscle cells which can do the work. It is difficult not to be tempted to put two diagonal lines in to deliniate its anterior and posterior borders, but remember, it is still form on which light is falling and which is turning away from the light. It helps to think of it as having planes; the thickness of the anterior and posterior borders providing two planes and the top surface of the muscle the third plane. The sternomastoids are the most obvious and you can feel the contraction the most, when they are lifting your head off the pillow. They both have to act together for this movement of drawing the head forward.

The TRAPEZIUS is a large flat muscle which covers the back of the neck, the shoulder and part of the back. It arises from the medial one-third of the superior nuchal line, from the ligamentum nuchae, and from the spines of the twelve thoracic vertebrae. The forms of the superior and middle parts of the muscle are seen in the neck. The muscle bundles of the superior part pass downwards and forwards to be inserted into the lateral one-third of the clavicle. The front, thick, almost rolled-edge of the superior part is a landmark as it comes forward on the top of the shoulder towards its attachment to the clavicle. The middle part has horizontal muscle bundles which insert into the upper border of the spine of the scapula. These two parts create a full rounded form on the top of the shoulder. The Trapezius maintains the stability of the shoulder. When the upper bundles contract the point of the shoulder is raised. Then, of course, the bulge on the top of the shoulder is increased.

The PLATYSMA is a thin muscle sheet on the side of the neck, its muscles bundles running diagonally towards the chin. It lies just under the skin and therefore covers part of the other neck muscles. Below, it passes over the clavicle and above, it is continuous with the facial muscles and attaches to the front margin of the jaw. It is responsible for the diagonal bands or 'strings' one sees in the older neck which lessen the concavity between the neck and the jaw.

The basic structures of the neck

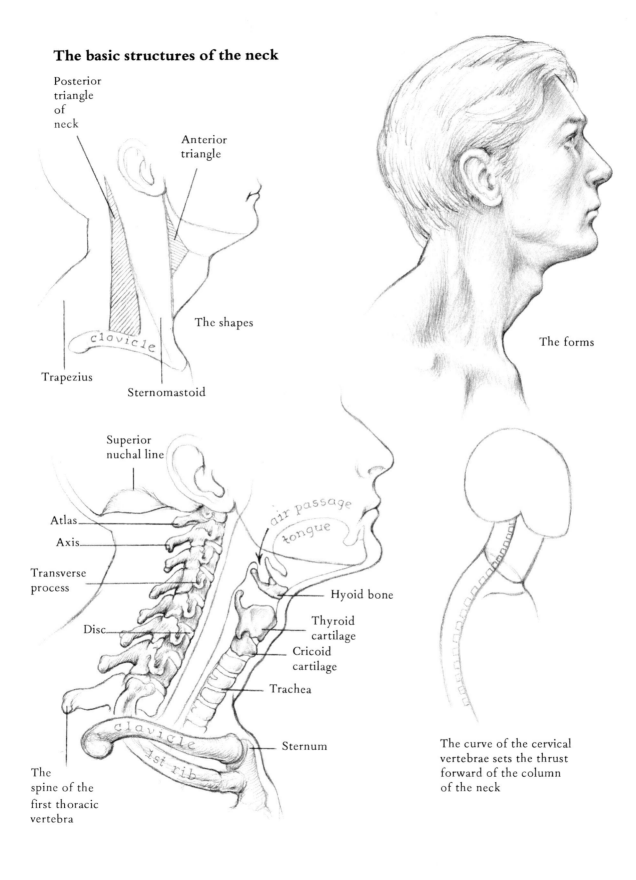

Posterior triangle of neck

Anterior triangle

The shapes

clavicle

Trapezius

Sternomastoid

The forms

Superior nuchal line

Atlas

Axis

Transverse process

Disc

air passage

tongue

Hyoid bone

Thyroid cartilage

Cricoid cartilage

Trachea

clavicle

1st rib

Sternum

The spine of the first thoracic vertebra

The curve of the cervical vertebrae sets the thrust forward of the column of the neck

The deep muscles and structures from the side and back

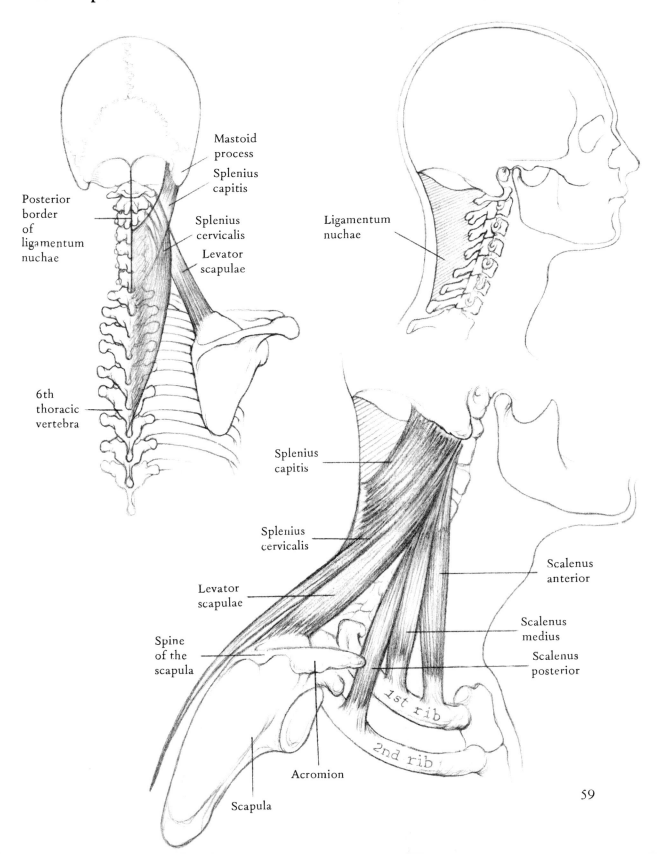

Mastoid process

Splenius capitis

Posterior border of ligamentum nuchae

Splenius cervicalis

Levator scapulae

Ligamentum nuchae

6th thoracic vertebra

Splenius capitis

Splenius cervicalis

Scalenus anterior

Levator scapulae

Scalenus medius

Scalenus posterior

Spine of the scapula

1st rib

2nd rib

Acromion

Scapula

59

The muscles and bony landmarks of the neck from the side and back

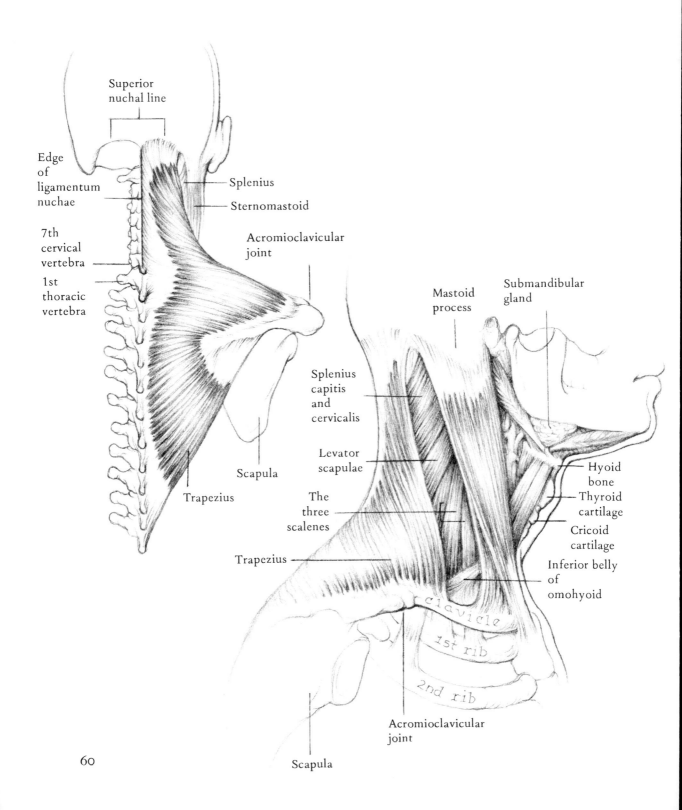

Superior nuchal line

Edge of ligamentum nuchae

Splenius

Sternomastoid

Acromioclavicular joint

7th cervical vertebra

1st thoracic vertebra

Mastoid process

Submandibular gland

Splenius capitis and cervicalis

Levator scapulae

Scapula

Hyoid bone

Thyroid cartilage

Cricoid cartilage

Inferior belly of omohyoid

Trapezius

The three scalenes

Trapezius

clavicle

1st rib

2nd rib

Acromioclavicular joint

Scapula

The muscles and landmarks of the front of the neck

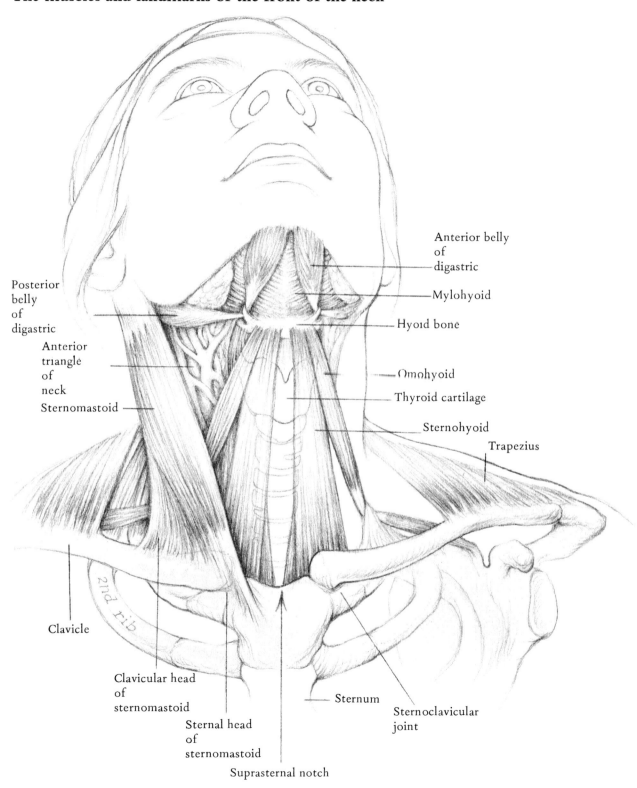

Anterior belly
of
digastric

Mylohyoid

Hyoid bone

Posterior
belly
of
digastric

Omohyoid

Anterior
triangle
of
neck

Thyroid cartilage

Sternomastoid

Sternohyoid

Trapezius

2nd rib

Clavicle

Clavicular head
of
sternomastoid

Sternum

Sternoclavicular
joint

Sternal head
of
sternomastoid

Suprasternal notch

The forms of the thyroid cartilage and trachea

Note the protruding form of the thyroid cartilage and also the angle back and down of the trachea as it descends to divide into the right and left bronchi to the lungs

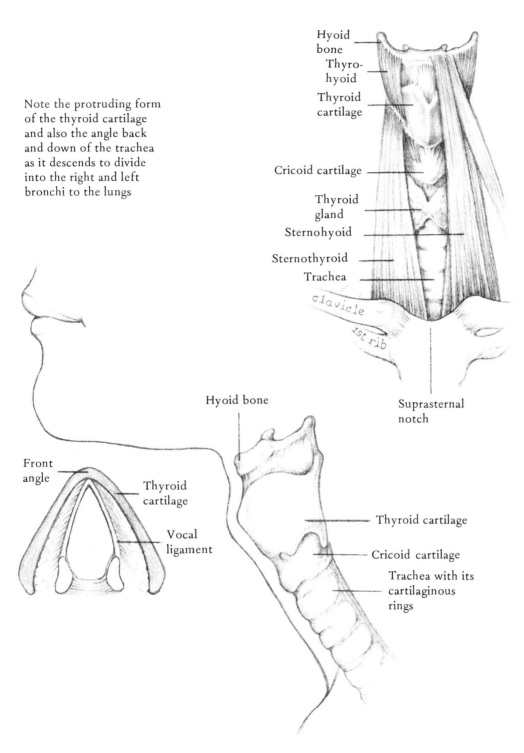

Hyoid bone
Thyro-hyoid
Thyroid cartilage

Cricoid cartilage

Thyroid gland
Sternohyoid

Sternothyroid
Trachea

clavicle
1st rib

Suprasternal notch

Hyoid bone

Front angle
Thyroid cartilage
Vocal ligament

Thyroid cartilage
Cricoid cartilage
Trachea with its cartilaginous rings

The neck is a column
supporting the head

and sitting on
the shoulders

63

The sternomastoids

The sternomastoids are relaxed and crowded down towards the shoulder

Only the anterior part of the muscle is being stretched

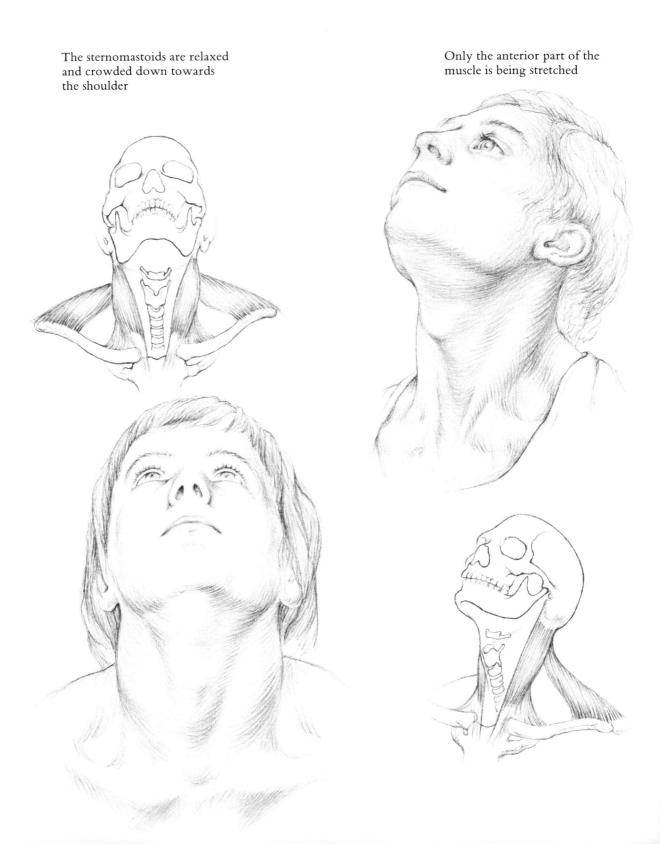

Beginning to draw the head

These suggestions incorporate the basic egg-shape and the basic box-shape along with certain ideas which have proved useful to other beginners. As one progresses many of the steps which are taken consciously at first will become 'second nature'. With increased confidence and observation much of the assessment or judgment will be done very quickly in the brain. The person you are drawing is never just a technical problem, and hopefully that thought will be within you constantly. These steps can eventually serve just as a method of checking when one is working very freely, so that when something in a drawing looks wrong or doesn't 'sit right' with you, you will have a means of finding the culprit.

To clarify descriptions, the terms used are these: skull is all the bones of the head; head means the head as a whole with its two parts, the face with its features and the cranial part (the rest of the head).

Steps

1 To obtain the angle of tilt of the head, hold a pencil at arms length, keeping the elbow stiff, and the pencil parallel with your face (in the same plane as your face). Sight it along a line which joins the mid-line of the chin with a point midway between the eyes. Swing your pencil back and forth until you are sure. It must always be held parallel. Take time to look at that angle. It is important as it is the basic line which sets the gesture for the whole head. In the following four small diagrams which show some of the steps, the tilt or diagonal is from the upper left to the lower right. When you are satisfied that you have the correct angle, bring your pencil down to your drawing page, holding it firmly in the angle you have chosen. This is a little awkward to do, in the beginning. Now put that tilt line lightly on your page.

2 Sketch in loosely the basic egg-shape of the head around the tilt line.

3 Indicate, again very loosely, the three plane changes; from the front of the face to the top of the head, from the front of the face to the side of the head, from the top of the head to the side of the head. This will help you to get the feel that you are dealing with a solid which has dimension.

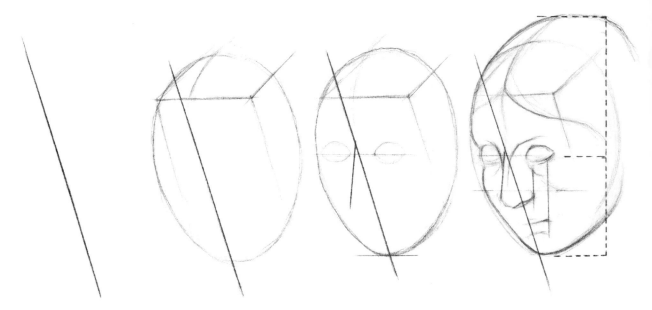

4 Holding the pencil at arm's length again, and always parallel to your face, sight along a line which would join the outer corners of the eyes. It may be horizontal or it may be tilted. Bring the pencil down to your drawing paper, holding it firmly with the angle you have chosen and put that line lightly on the page.

5 Indicate lightly on the page by a line where the chin might come in relation to the eye line.

6 Now you can start taking relative measurements. Holding the pencil vertically, take the measurement between the eye line and the chin line. Using that measurement see if it is the same distance from the eye line to the top of the head, or if it is one half that distance, or one and a half or twice, etc. In the example shown it is about one and a half. That enables you to put in the line more boldly where the top of the head will be, as those two measurements are now correct in their relationship with each other. This is how you will assess the whole head, once you get the angle of the nose in.

7 Sight your pencil along the tilt of the nose, holding the pencil parallel with your face. Take that angle down to your paper and put it in lightly. It will meet the first tilt line, at the eye line. The pencil should be held at arm's length each time.

8 You can now take the rest of the relative measurements. In the following example for relative measurements, the distance between the outer parts of the eyes is the same as the length of the nose from a point midway between the eyes to the tip of the nose. Once you have both the angle and the tip point, you can draw more freely. The width of the nose at the nostril area is the same as the distance (vertical) from the chin to the rim of the upper lip. The line which you will construct the mouth on, is parallel to the eye line, passing through the two outer corners of the mouth. The vertical distance from the upper lip to the nostril above it is the same as the horizontal length of her right eye.

The horizontal length of the right eye is approximately the same as the width of the nose at the nostril level and the width of the mouth. When you put the nostrils in, look up and check relationships with the eye. When you put the corners of the mouth in, check their relationships also with the eye. This is a double check on your relative measurements.

9 Look for the underlying bone structure. Indicate lightly where the zygomatic bones of the cheeks are and match them. Look at the jaw and decide if it looks long or short and sketch it in from the chin point. You can get the angle of it by using the 'tilt' method you used for the centre line of the head. See what forms are showing of the bony margins of the orbital cavities. Check to see if the bony part of the nose is creating a special form.

This is a structural approach on which you can move freely to develop your forms. The steps are only suggestions. You will probably omit some of these and add some of your own to help yourself. They may be limiting in spontaneous drawing for a time, but eventually the form building and the basic structuring are done simultaneously and your free drawing will have more surety and soundness.

Two thoughts for consideration. When the head is tilted down or away from you, a great deal of the cranial area is visible. Don't be stingy putting it all in. I have seen many half craniums in drawing which allow for only a tiny brain. And secondly, when you start building the forms with tone, even starting with straight diagonal lines, keep the feeling in your fingertips that the forms are receding and advancing and flowing together to make a whole unit.

Note The 'claw' method of measuring is included and you may find it quicker than using the long pencil for measuring and then changing to a short pencil for drawing. One has to be careful though to see that the imaginary line between the thumb and the index finger is kept parallel with the face at all times. This 'claw' method is also useful for you to make quick relative measurements on your drawing page. It is perhaps not as exact a method as the pencil method which is taught in most art colleges.

Two methods of taking measurements

The pencil method

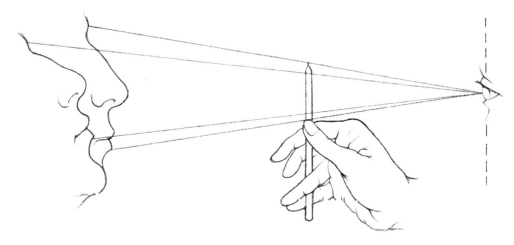

1 Your arm is held out directly in front of you, the elbow is kept stiff

2 The pencil, or the imaginary line of the 'claw' between the thumb and index finger, is kept parallel to (in the same plane as) your own face and eyes

The claw method

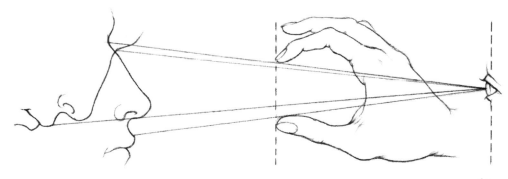

Example of beginning to draw a head and take relative measurements

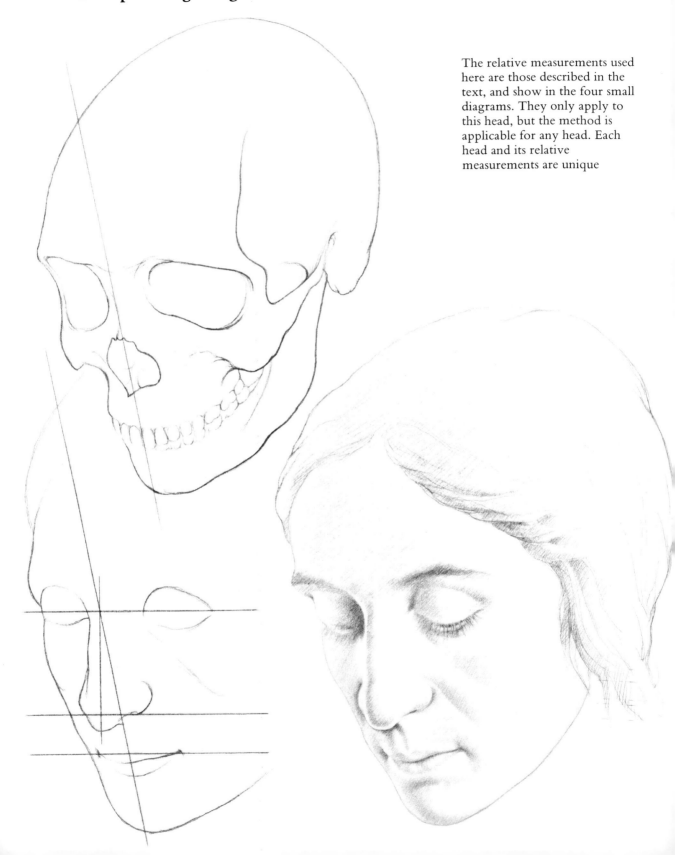

The relative measurements used here are those described in the text, and show in the four small diagrams. They only apply to this head, but the method is applicable for any head. Each head and its relative measurements are unique

Lines to practice

Some examples are shown of the different kinds of lines used in drawing to create tonal areas with which to express the form. Try ordinary graphite pencils from B to 4B and see which one gives you the greatest range of tones between white and black. The lines should have a clarity. If your lines appear smudgy and too black, you are using too soft a pencil. Your pencil should be well-sharpened and have a long point and it should be short (about 65 mm (2½ in.) long) so that you can hold it under your hand. It will rest between your thumb and your first three fingers. You use the side of the point, rather than the end of the point as you do in writing.

For practise, to learn to stroke freely and yet get some control in direction and weight of line, work standing, with your paper taped to the wall. Or tape your paper to a table and stand over it. This is to help you develop a shoulder movement which is basic in drawing. If you are sitting, place the paper tacked onto a sturdy board far enough away from you so that your hand does not rest on the paper. The motion is just a swing from the shoulder with the fingers, wrist and elbow having no separate movement. Begin large and come down in size as you get more discipline of putting the lines in a fairly regular pattern beside each other. This method will help you develop a free flowing line which you can never achieve with limited finger movement. The delicate wrist and finger movements are used for fine detail, if you wish it.

The straight line is the easiest with which to begin, for most people. It is also a most valuable kind of line to use for putting in large tonal areas so the unity of a whole head is established quickly.

The tactile line has more rhythm and flow quality.

How you will eventually combine these lines, or with what weight you will use them, will be unique for you. I can only suggest that you be very experimental and try them all.

Note You may benefit by modelling your own face, or parts of it, in clay or plasticine. You will certainly be forced to look more closely and much of drawing is just developing perception. There is also the very good chance of the extraordinary feel for form in space arriving within you. It is creating this illusion of a form in space, on a flat page, which inspires many who are now drawing or wish to draw.

Pencil techniques with lines to practise

THE UNVARIED STRAIGHT LINE

Diagonals

Vertical

Horizontal

Cross-hatched

THE VARIED LINE

The varied straight line going
from light to dark and dark to
light

THE TACTILE LINE

Simple curve

Cross-hatched

Two directions and moving
from light to dark to light

Cross-hatched

Simple curve moving from
light to dark to light

The straight unvaried diagonal
and the tactile line cross-hatched

73

Development of the tactile line

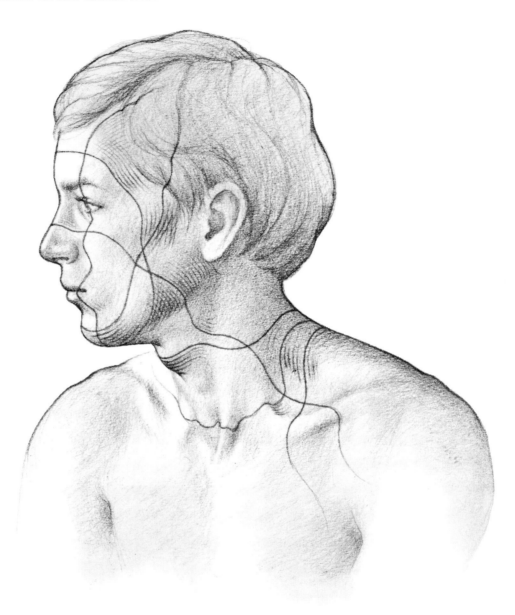

The continuous lines marked here on the face and neck are just a few of the paths my fingers might take in stroking the face to feel the form of it. Each of you would make different ones. It is from imagining these paths over the form, and their direction, or indeed actually feeling them if one can, that one can learn to build the tonal areas with line. Those tonal areas are where the form is turning away from the light source. The direction of the path is repeated in separate strokes, or two or three directional strokes are used cross-hatched. This is one method of creating unified tone

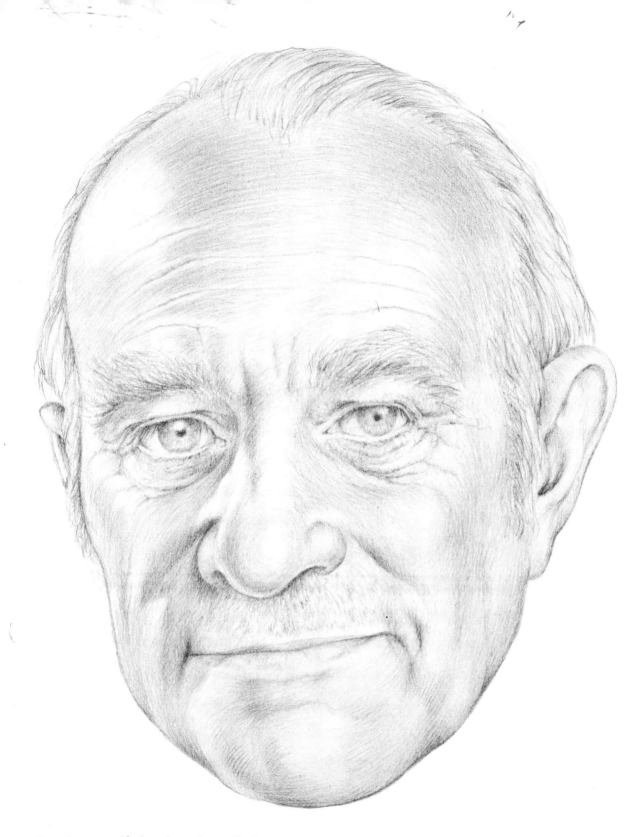

Drawing magnified to show the tactile line

If a face looks square to you, after you have put the tilt line in for the centre axis, take relative measurements across the width of the face and check what that width is equal to in the length of the face. In this head it is from the bottom of the chin to the brow. Put the square in lightly. Then proceed with other relative measurements. For instance in this example, the distance from the brow line to between the lips is the same as the width across the eyes between the outside corners. You may have to hunt a little in the beginning for distances which are equal, or double, or half, etc, but this will help you train your eyes and you will become less and less dependent on the steps suggested

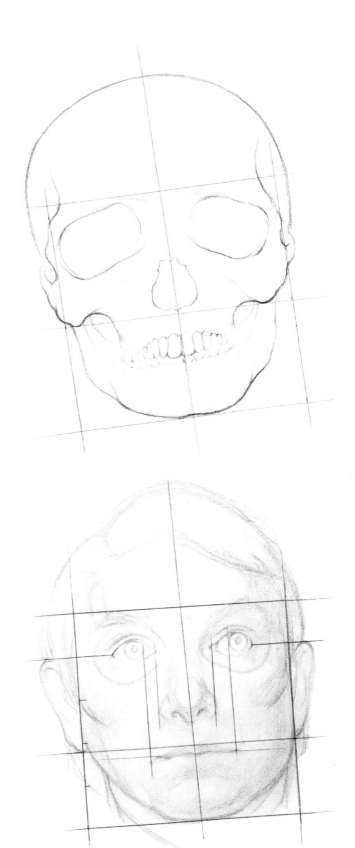

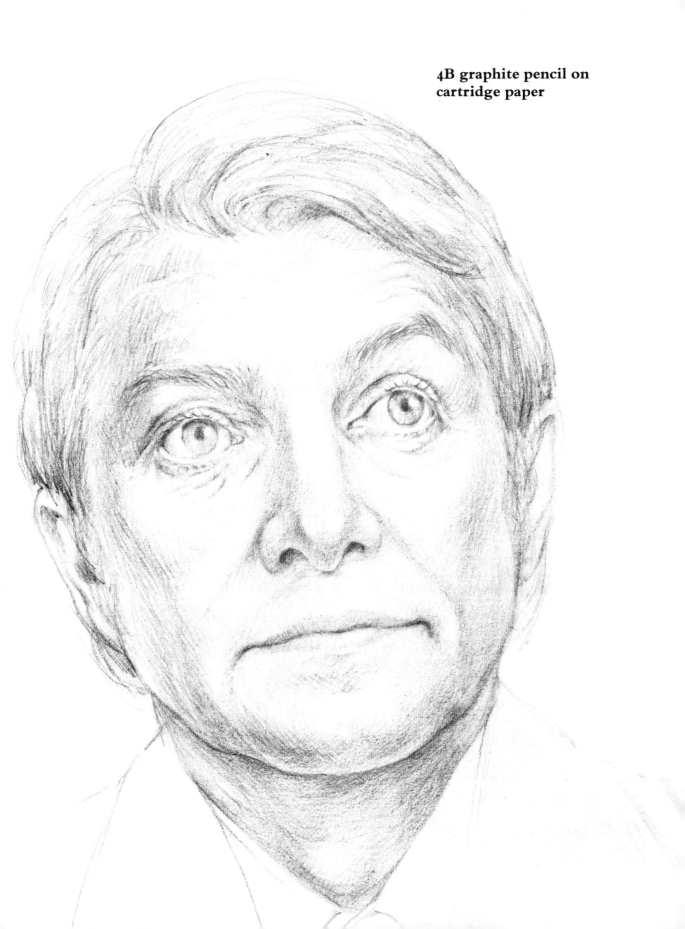

4B graphite pencil on
cartridge paper

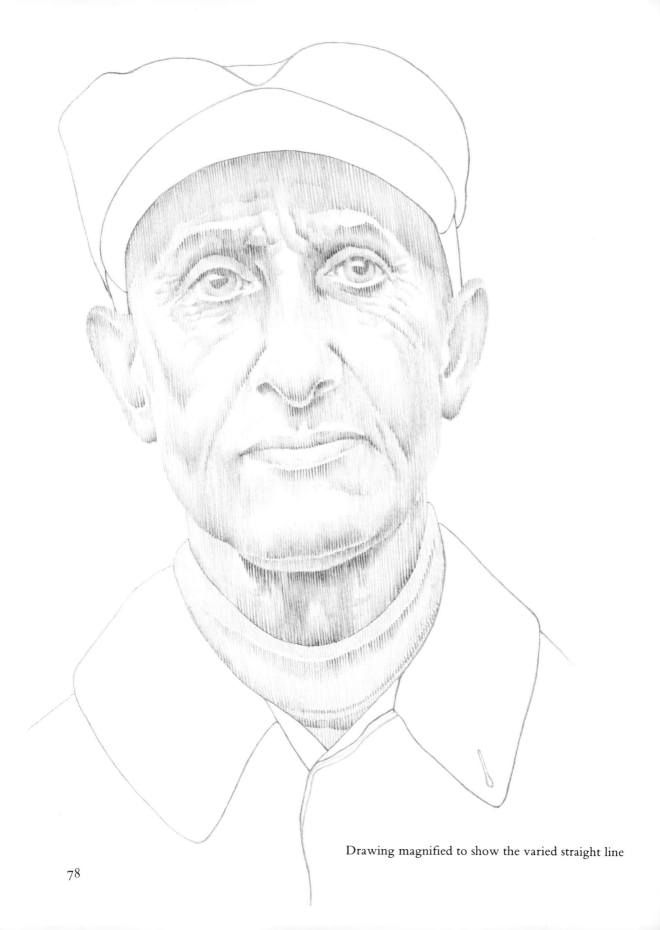

Drawing magnified to show the varied straight line

Creative form with varied and unvaried straight lines

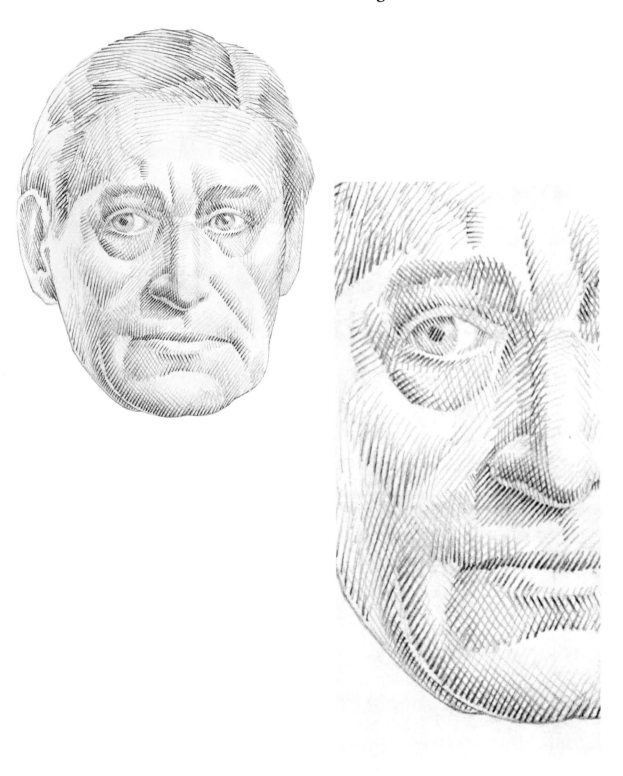

The straight, varied, diagonal line

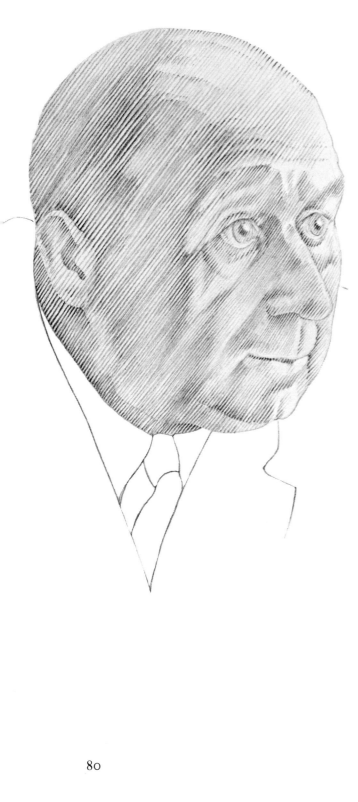

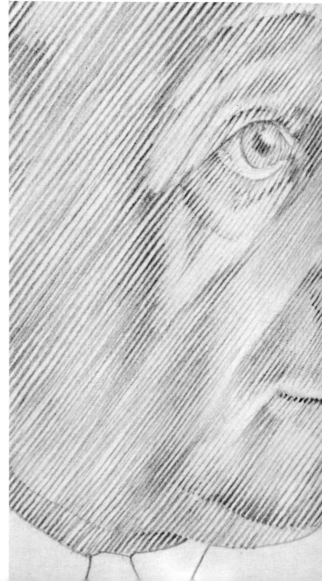

This is an exercise in drawing
the face with the idea of
constructing a mask from your
drawing. It helps you look just
for the big forms and funda-
mental plane changes
Courtesy Betty Maxey, illustrator

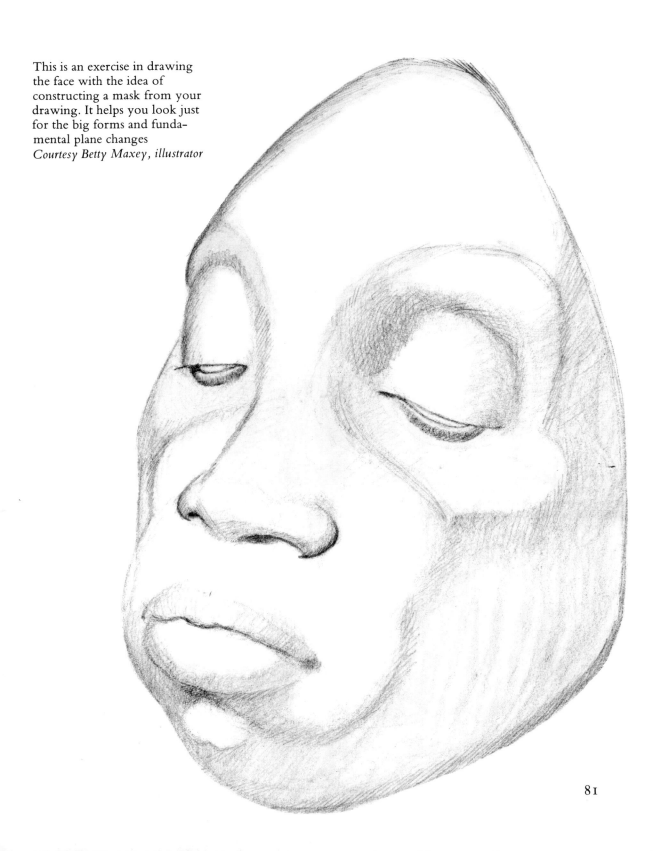

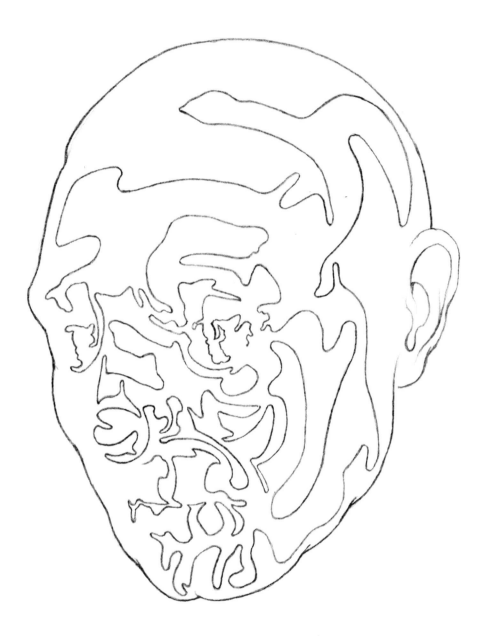

This is an exercise to help you become more aware of the forms
of the face. Start off with your pencil in any spot and travel with
a continuous line over the forms, describing them in two or three
directions of line. This develops both your perception and your
tactile line, and you can practice using your own face. Each trip
will be a different one, in results

The planes of the head

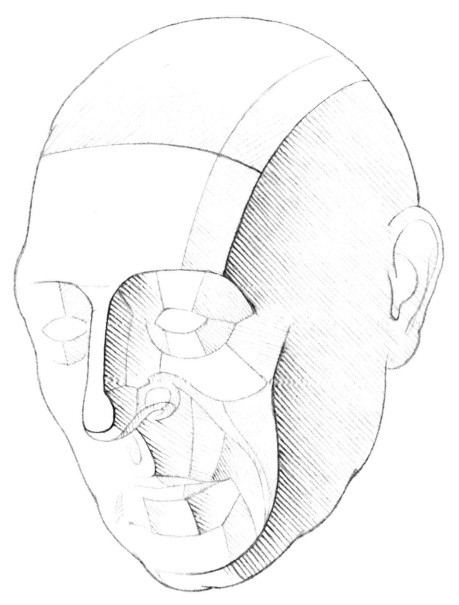

A plane means a flat or level surface. Though these do not exist
in the head in the precise meaning of the word, in drawing we
think of the plane of the face, the plane of the top of the head, the
plane of the side of the head and all the other smaller planes into
which form can be divided. A head can be constructed using these
definite planes, and the edges of them, in order to understand
better the volume or dimensions of a form. The place or edge
where one plane meets another is where there is a change in
direction in form. The example shows some of the planes on this
specific head, but primarily the big planes. The light here is falling
on the front plane

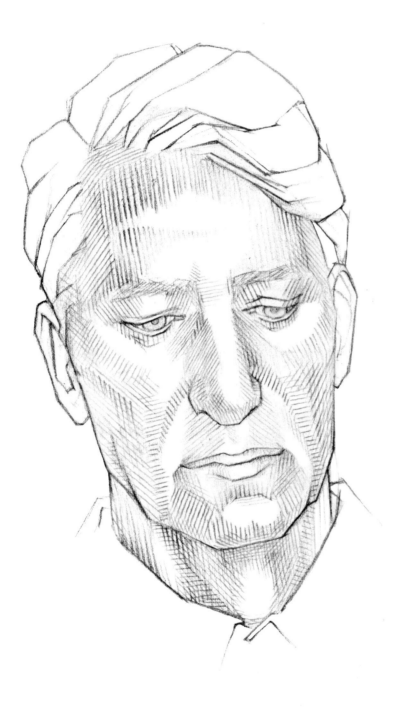

Some of the planes on this face. The outline is also drawn with
definite plane changes

84

Tones and lighting

When light rays fall on a head, say from in front, the planes facing to the front reflect them back to you. This creates the areas of 'light' which you see on a face. It is interpreted as white on your drawing paper. The other planes which are receiving scattered light rays and not those directly from the main source, will appear in shadow and those will be interpreted by tone. The different tones of shadows are different degrees of luminosity. Deeper and deeper tone means less and less luminosity. If a form is turning completely away from any light source it will appear as black. It is through the range of tone which he uses that an artist can depict the subtle changes in form, and if he is aware of the plane changes in a form he can begin to see the different tones. The larger planes of the face, the top of the head and the sides of the head are the important ones, because they represent the head as a unit. It helps if you think of that unit first in beginning to draw, and to put in the big tonal areas. It keeps your drawing from being spotty and fragmented. Then you build onto that basic tone, drawing the smaller forms which you wish to suggest, within it.

When you are building with tone to create the illusion of dimension, it is sometimes an aid to think of the head as one would of a landscape where the parts closer to you are more in focus, a greater range of tone is visible, and the whites and blacks are definite. The part furthest away from you in a landscape is paler and more one tone caused by the diffusion of light. You can, if you wish, apply this principle to drawing the head by keeping the part of the face which is closest to you more 'in focus' with a rich range of tones to show the forms and letting the parts furthest away from you become more one tone and less in focus. This is worth experimenting with as it can bring a certain simplicity into your drawing and help you to discriminate as to where you wish the attention to be focused.

Reflected light

One often sees a rim of light at the edge of a form as it turns from sight, or light on an underside plane. This is caused by reflected light. Reflected light on a head is the result of the light rays going past the head, or past a part of the head, striking some surface beyond, and being reflected back. This reflected light does not have the luminosity of direct light, so it appears not as white, but as a lighter tone. One sees it under the chin at

times, when the light rays have gone past the chin and encountered the front of the chest which reflects them back to the underside of the chin. It also happens under the nose when light rays are reflected there from light which is falling on the upper lip. Look for it, as it is of great value in expressing an added truth to the form.

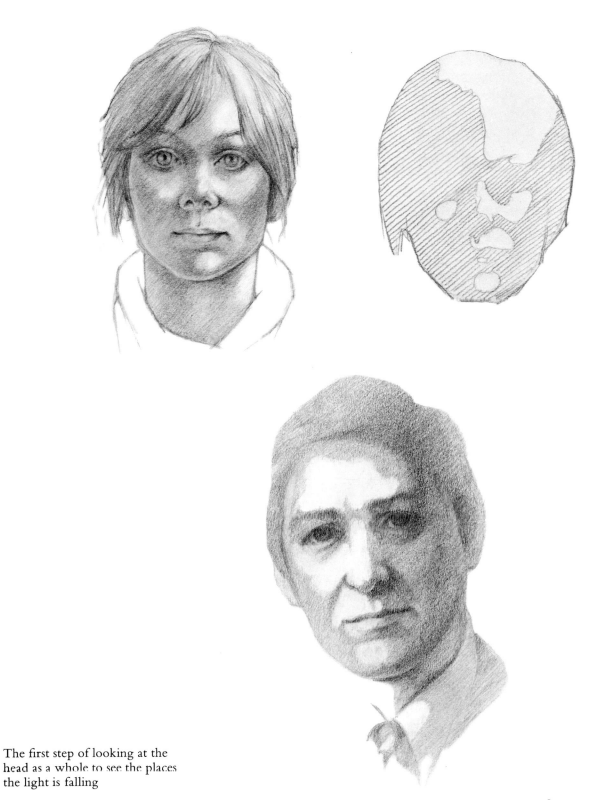

The first step of looking at the
head as a whole to see the places
the light is falling

The head seen as a unit with the large tonal area indicated

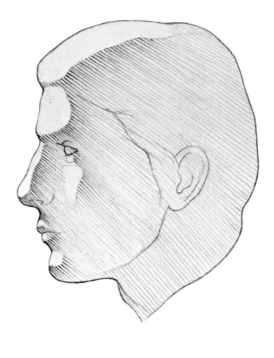

Light is being reflected from the cheek to under the eyebrow, from the upper lip to under the nose, from the clothing to under the chin. There is a lighter tone showing it in these areas

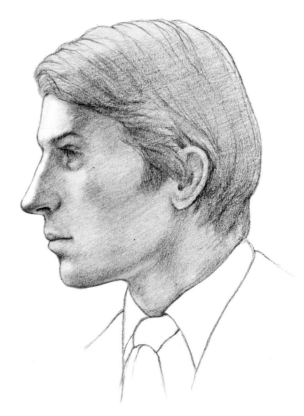

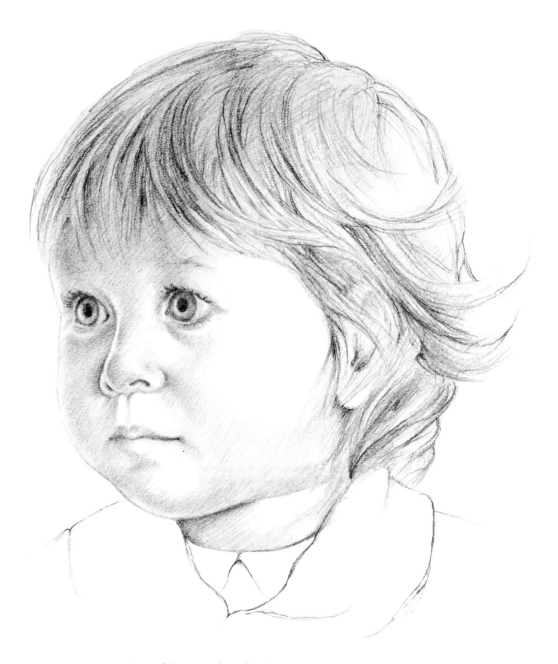

Light is falling on the side plane
of her head and the front plane
is in shadow. The light rim on
her nose and the right side of
her face is caused by back
lighting

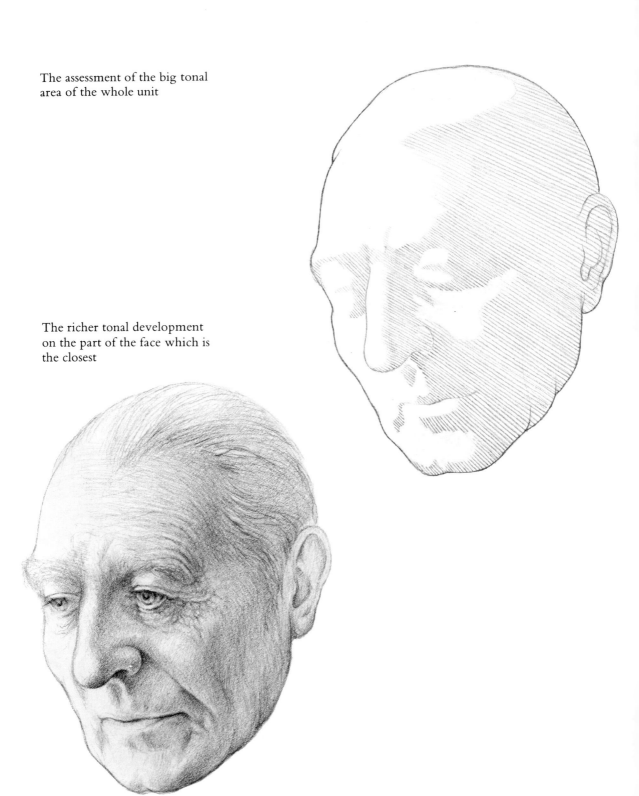

The assessment of the big tonal
area of the whole unit

The richer tonal development
on the part of the face which is
the closest

90

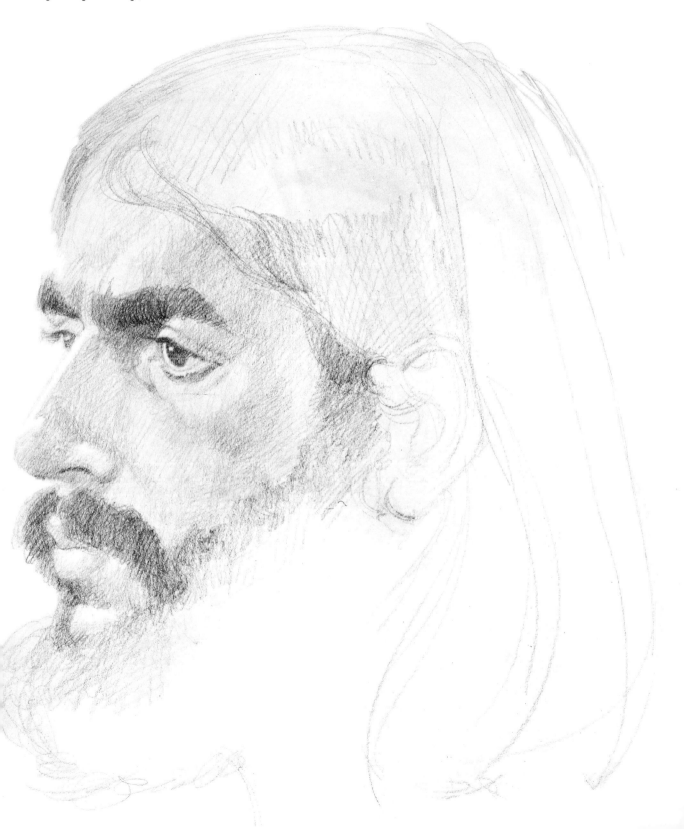

Incomplete portrait on cartridge paper with graphite pencil
by Betty Maxey, international illustrator

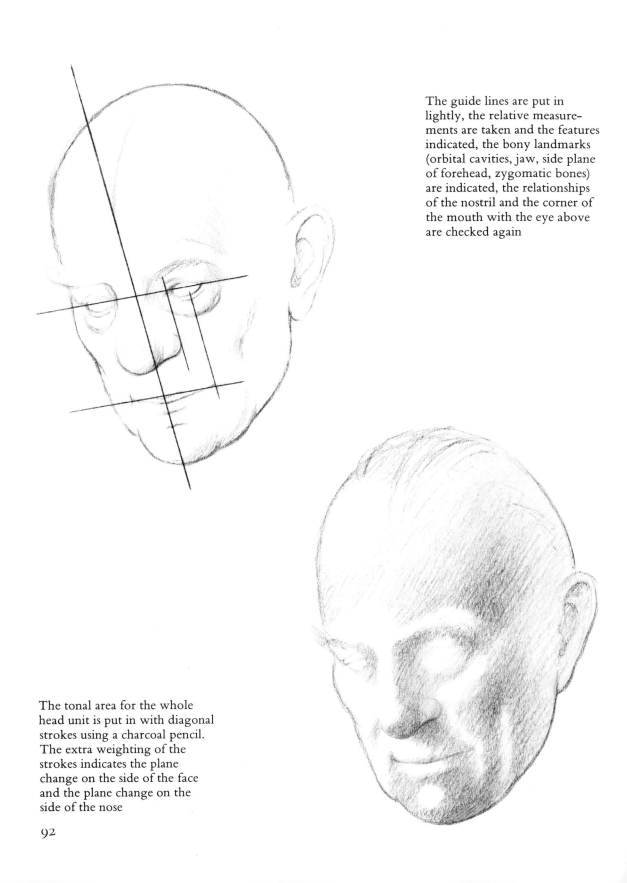

The guide lines are put in lightly, the relative measurements are taken and the features indicated, the bony landmarks (orbital cavities, jaw, side plane of forehead, zygomatic bones) are indicated, the relationships of the nostril and the corner of the mouth with the eye above are checked again

The tonal area for the whole head unit is put in with diagonal strokes using a charcoal pencil. The extra weighting of the strokes indicates the plane change on the side of the face and the plane change on the side of the nose

Charcoal pencil with 2B graphite on cartridge paper

The different depths of tone with which you work the whole unit can evoke different moods

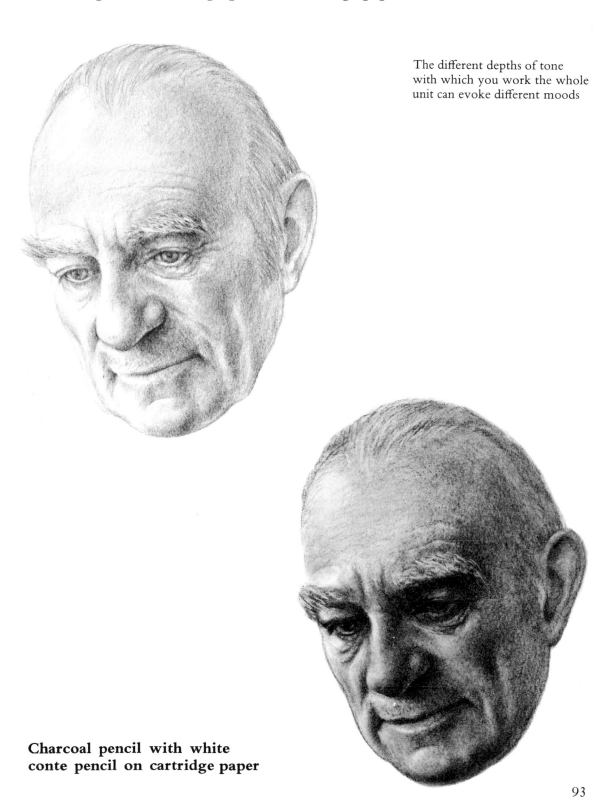

Charcoal pencil with white conte pencil on cartridge paper

Perspective

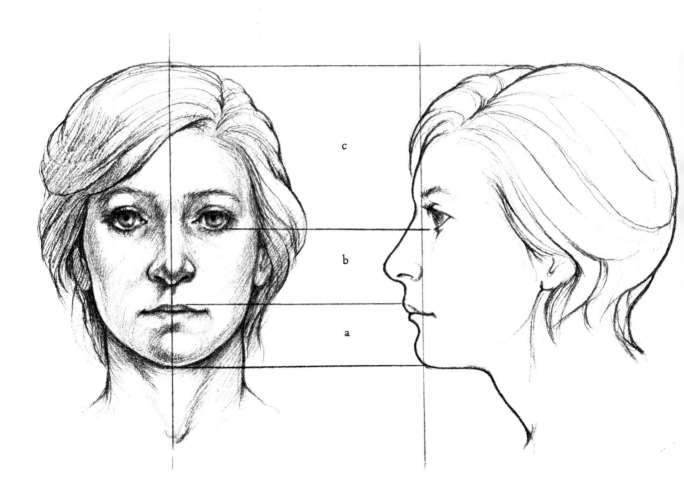

c

b

a

This shows the front view of
the face with the side projection,
when the face is in the same
plane as (parallel to) your own
face and eyes. The vertical
distance between certain points
are marked (a), (b) and (c).

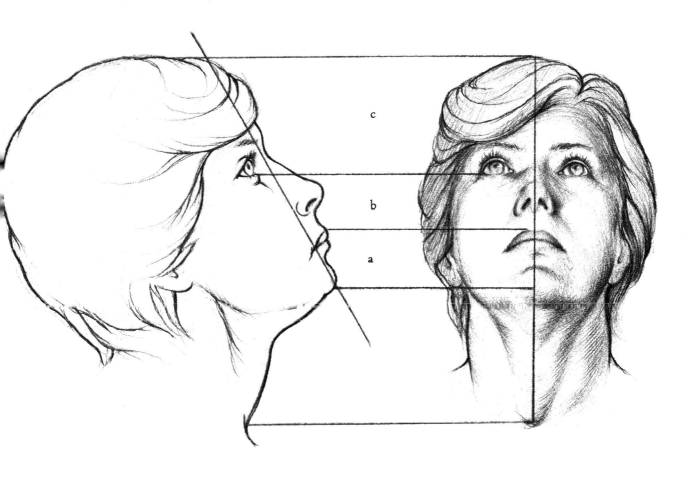

c

b

a

This shows the front view of
the face with the side projection,
when the face is turning back
from the vertical plane of your
own face and eyes. Compare
with the previous illustration.
The vertical distance (a), is

almost the same, because the
turning back is slight here. The
distance designated by (b), has
diminished relatively more, and
the distance designated by (c),
has diminished the greatest.
This is because the parts of the

face in the (b) and (c) areas are
moving further and further
away from the vertical plane of
your own face and eyes

The two main things to look
for in drawing the upturned
head are the tilt of the head
(where the central axis is), and
where the tip of the nose comes
in relationship to the eyes. It is
very often above the eyes,
though it always seems tempting
to bring it lower. Check this
point carefully as when it is
right, you can then get the
correct relative measurements
to place the mouth and the
chin. This keeps a head which
is in a perspective view as
'squashed down' as it should be,
with the features appearing
much closer together. The same
principles hold true in drawing
the downturned head. Check
there for the position of the
tip of the nose to the upper lip

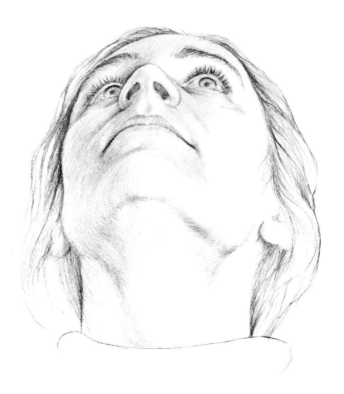

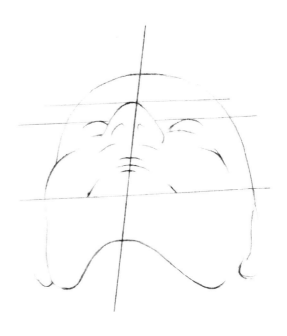

Forms and bony landmarks of the upturned head

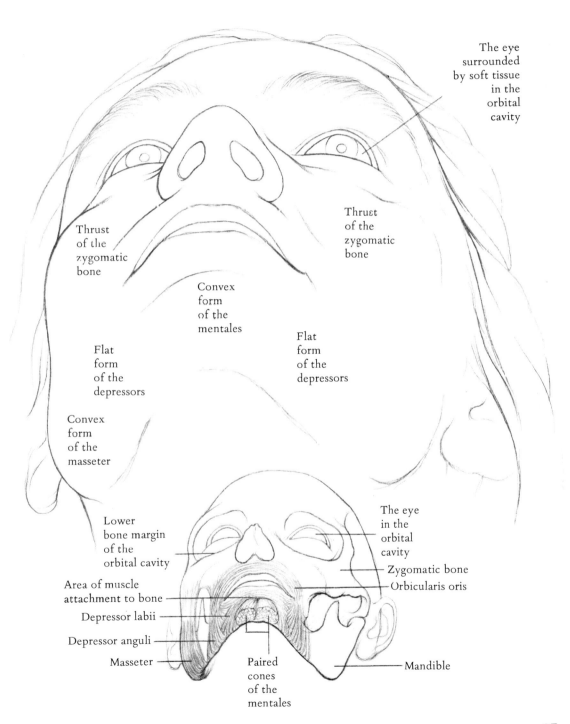

The eye surrounded by soft tissue in the orbital cavity

Thrust of the zygomatic bone

Thrust of the zygomatic bone

Convex form of the mentales

Flat form of the depressors

Flat form of the depressors

Convex form of the masseter

Lower bone margin of the orbital cavity

The eye in the orbital cavity

Zygomatic bone

Orbicularis oris

Area of muscle attachment to bone

Depressor labii

Depressor anguli

Masseter

Paired cones of the mentales

Mandible

Outline: four kinds of line which can be used for outline drawing

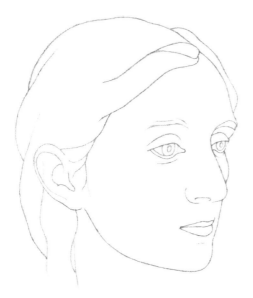

Unvaried line

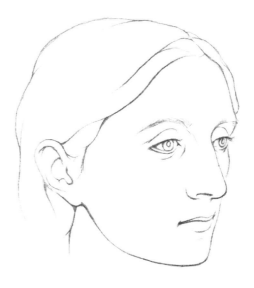

Simple varied line

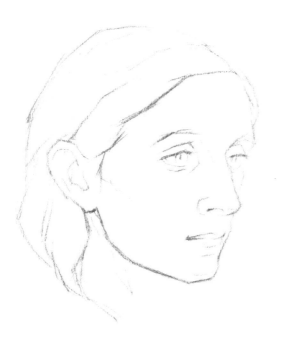

Straight line making use of
plane changes

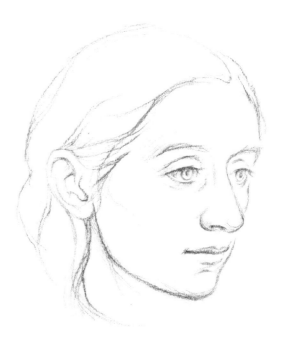

Tactile line making use of form

The development of outline; 2B graphite pencil on CS 10 board

Line can be derived not only from the main outline of the head but also from the forms within. Where those forms are in shadow, that shadow can be expressed. The outline can be swung into the interior in places to show form, to give more movement in the drawing and help to express the fact that the form is continuing around the edge, as in the overlapping lines of the chin area. This approach gives a more dimensional effect

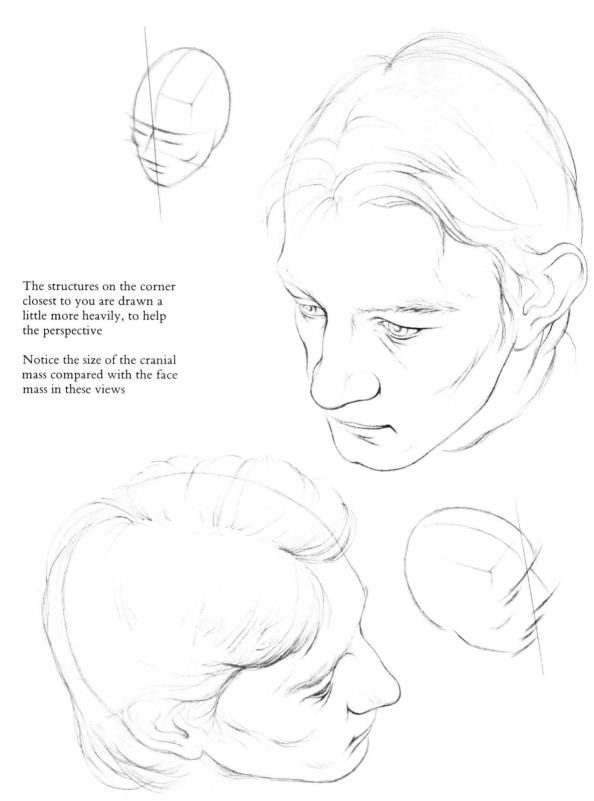

The structures on the corner closest to you are drawn a little more heavily, to help the perspective

Notice the size of the cranial mass compared with the face mass in these views

100

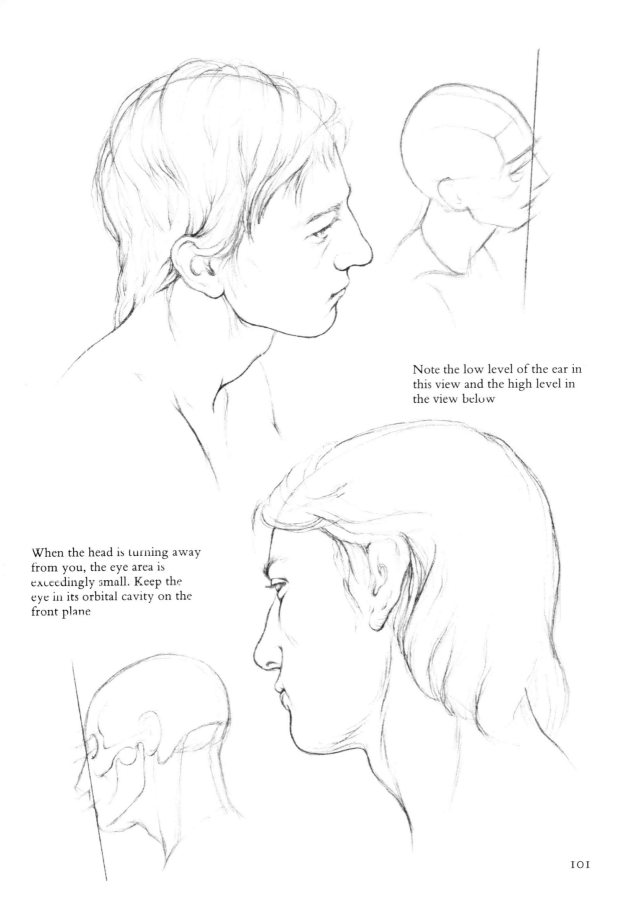

Note the low level of the ear in this view and the high level in the view below

When the head is turning away from you, the eye area is exceedingly small. Keep the eye in its orbital cavity on the front plane

The aged face

The gravitational effect causing the soft tissues to drop down from the skull is very apparent in the older and aged face

Archbishop Warham by Holbein. The fine perception of the interaction between the bone structure and the overlying soft tissues, expressed in this drawing with great discrimination, make a powerful unit

The weathered face

It helps, for practice, to 'overwork' some of the forms as it will force you to look more carefully and to keep on developing a drawing rather than being satisfied with a superficial effect. From this will come your personal discrimination as to what forms you will put in or leave out. It is how you separate the wheat from the chaff, whether you call it style, talent or taste, that brings the culmination in your drawing

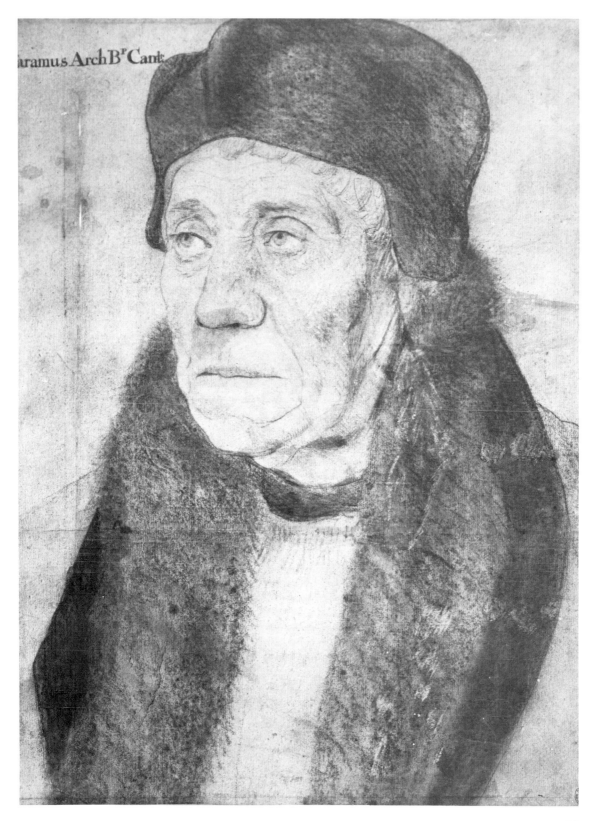

aramus Arch Bᵖ Cant:

Pen and ink on cartridge paper

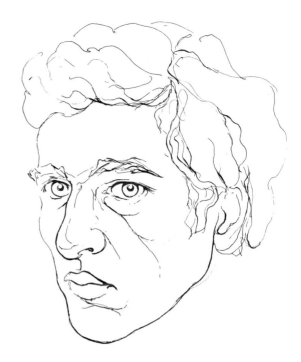

Fine felt pen on watercolour paper

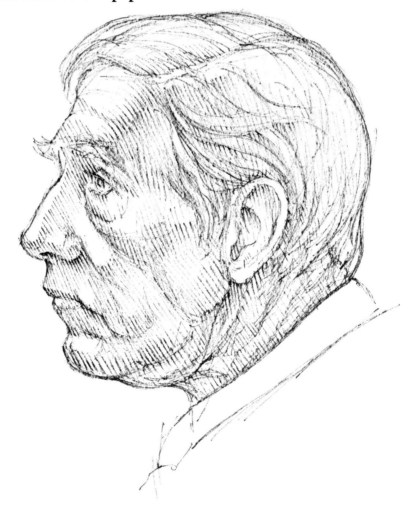

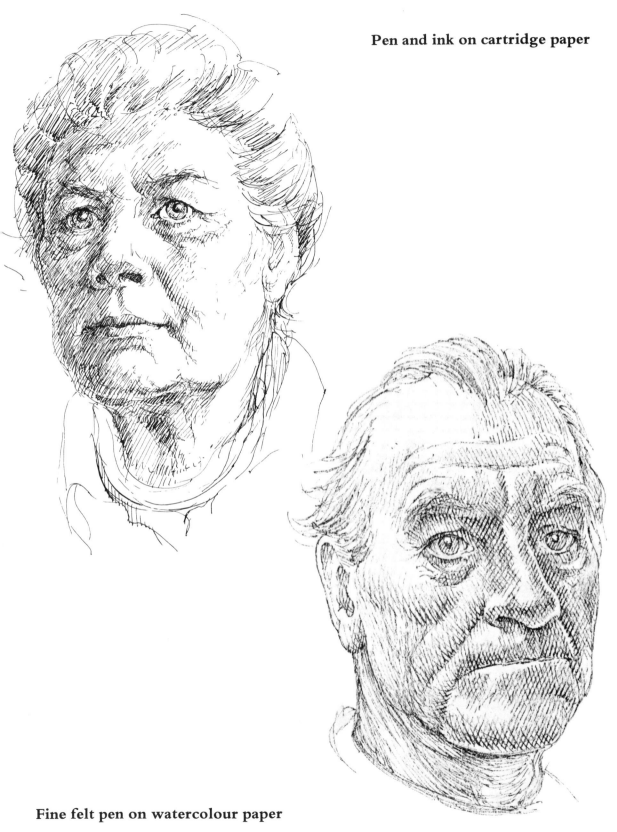

Fine felt pen on watercolour paper

Black ink on cartridge paper

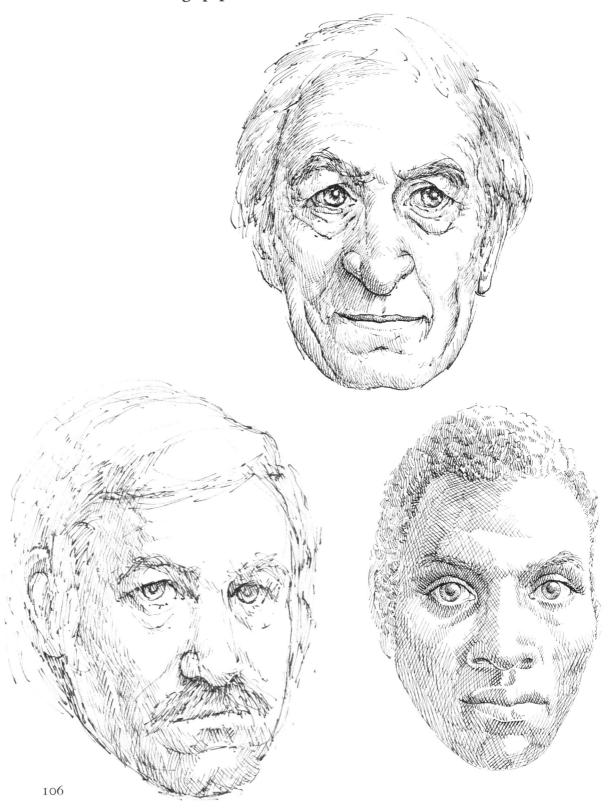

Caricature Rotring pen on cartridge paper

Caricature is often developed
using the knowledge of the
basic structures of the head

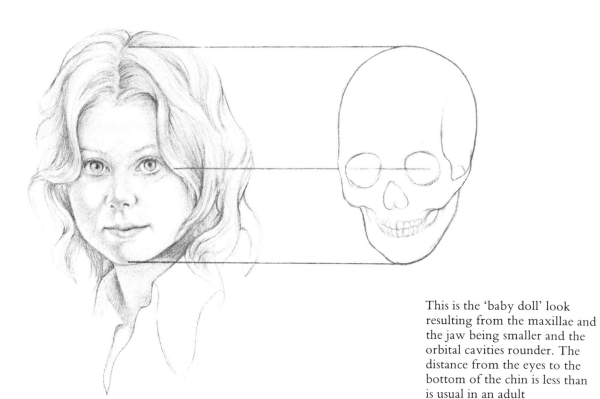

This is the 'baby doll' look resulting from the maxillae and the jaw being smaller and the orbital cavities rounder. The distance from the eyes to the bottom of the chin is less than is usual in an adult

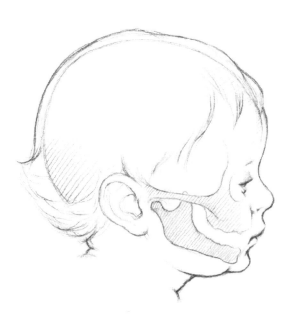

The face is small in the baby due to the lack of development in the upper and lower jaws, and the great development of the cranium which is accommodating the fast growing brain

108

The face of a baby

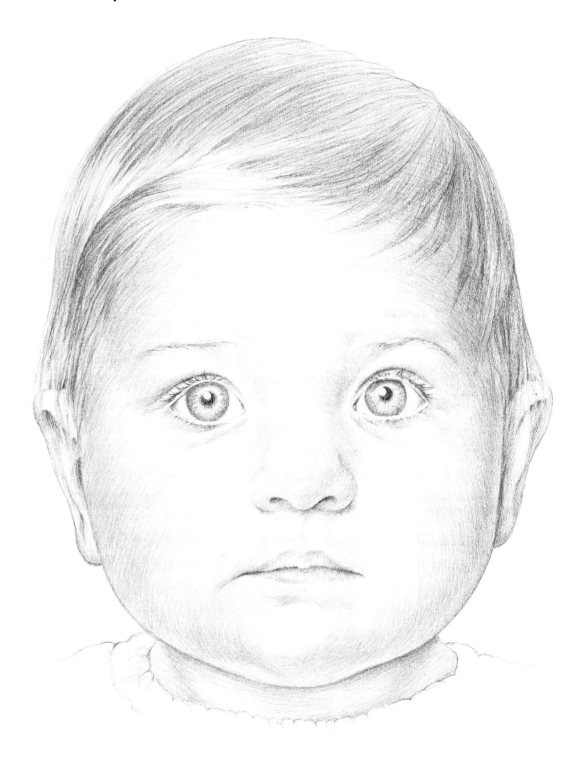

Brown conte dust and black conte pencil

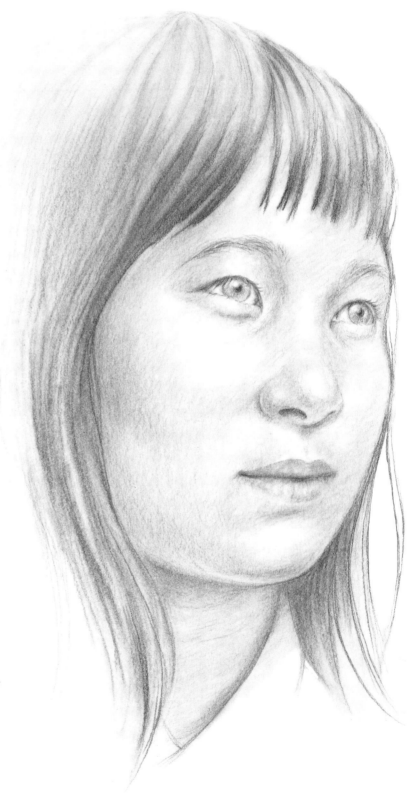

The skin fold above the upper
lid is pulled more tightly and
into a fold at the inner corner
of the eye. The nose is more
flattened

2B graphite pencil on illustration board

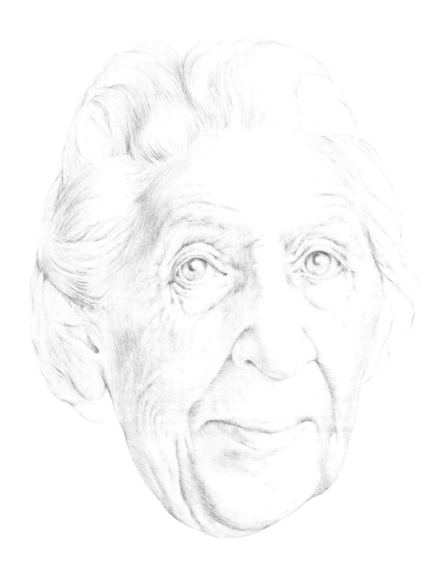

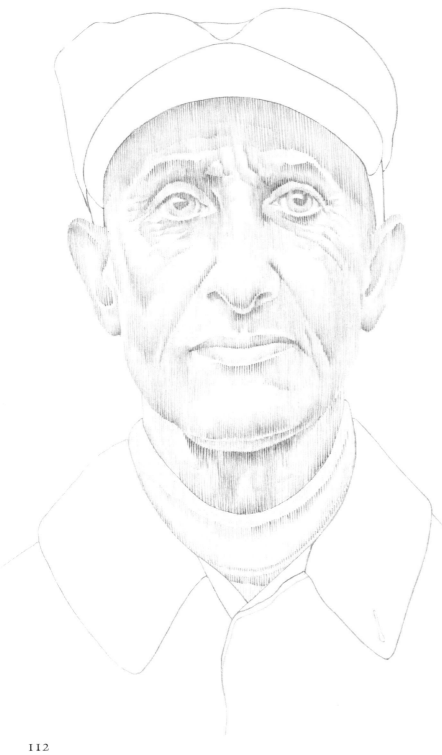

Watercolour on illustration board with 2B graphite pencil

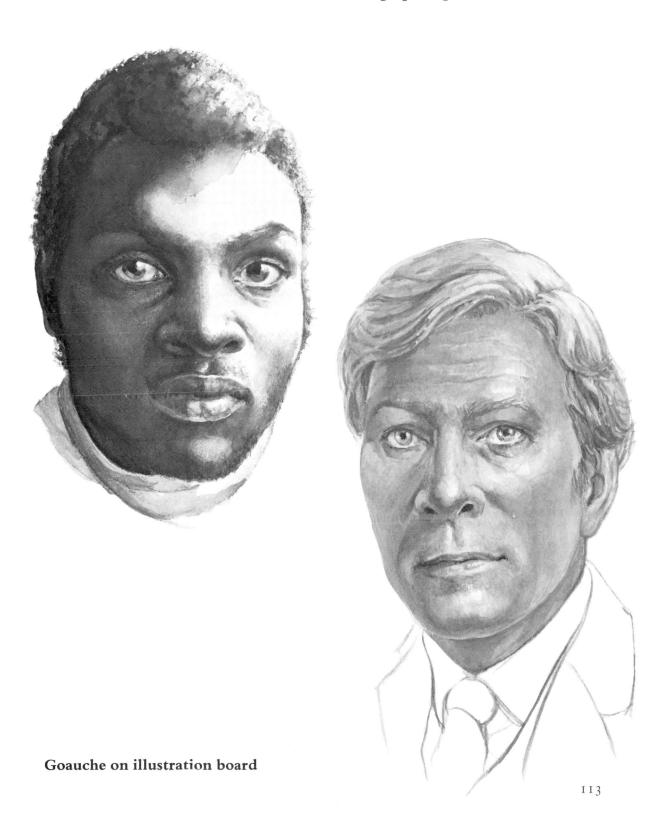

Goauche on illustration board

A simplified use of the tactile line. Brown crayon pencil on heavy cartridge paper

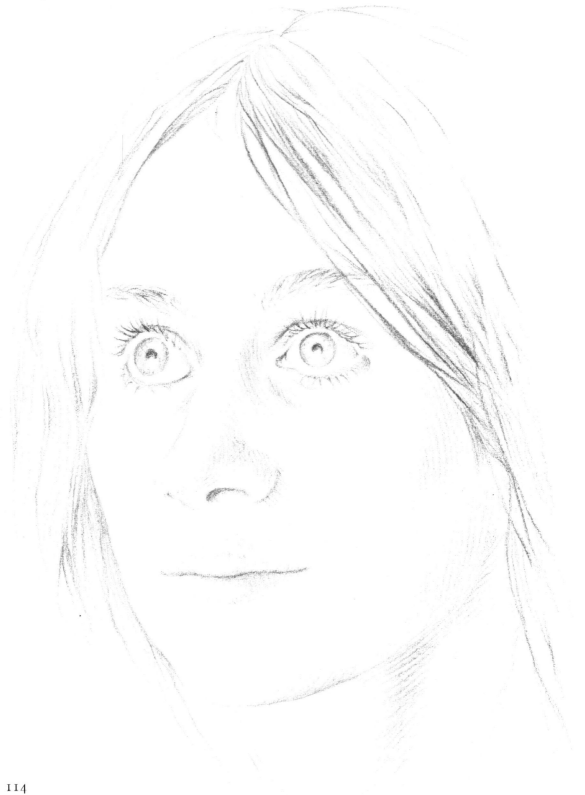

Charcoal pencil on cartridge paper, put on in diagonal strokes and rubbed with a soft cloth to develop the forms, and a 4B graphite pencil for details

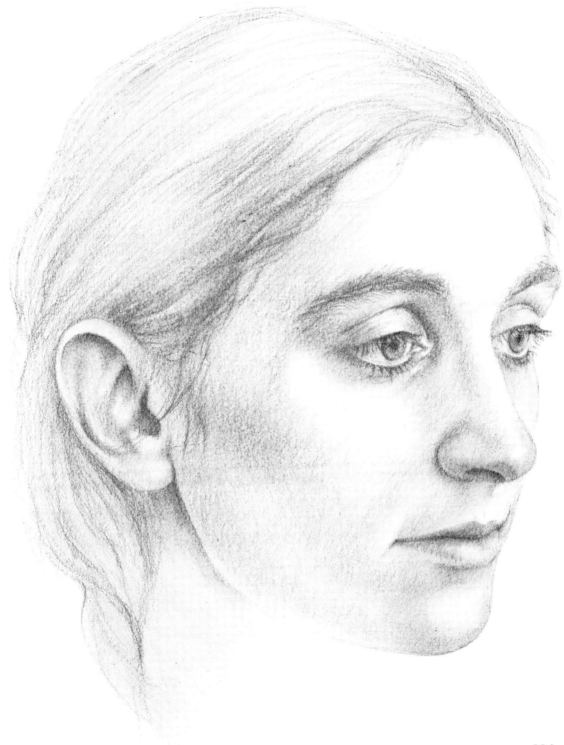

Brown and black conte crayon, used separately, and ground to dust on a sandpaper block, with 4B graphite pencil for detail, on illustration board

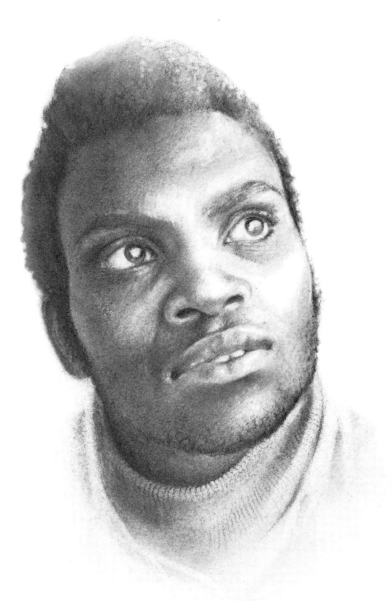

Glossary

Anterior Towards the front or ventral side

Aponeurosis A tendon in a sheet-like form to allow for wider attachment

Articulate To make a joint so motion is possible between two parts

Cervical Pertaining to the neck

Clavicle Collar-bone

Cranium The part of the skull enclosing brain

Cranial area Used loosely to designate the head, excluding the face

Depressor A muscle which lowers

Form The visible three-dimensional aspects

Inferior Below

Insert The muscle attachment to a movable point

Labii Lips

Lateral Towards the side

Levator A muscle which lifts

Medial Towards the midline

Origin The stationary point of a muscle attachment

Ossification The formation of bone

Plane A flat, level surface

Raphe The line of union and interweaving of muscle bundles

Shape The outlines of the external surface

Soft tissue The combination of skin, fat and vessels (and muscle) with soft tissues as compared to the hard tissue of bone

Sternum Breast bone

Superciliary Pertaining to the region of the eyebrows

Thoracic The part of the body between the neck and abdomen

Suppliers

Great Britain

L Cornelissen and Son
22 Great Queen Street
London WC2

Crafts Unlimited
178 Kensington High St
London W8

202 Bath Street
Glasgow C2

88 Bellgrove Road
Welling, Kent

Lechertier Barbe Ltd
95 Jermyn Street
London SW1

Reeves and Sons Ltd
Lincoln Road
Enfield, Middlesex

Robersons and Co Ltd
71 Parkway
London NW1

George Rowney and Co
Ltd
10 Percy Street
London W1

Winsor and Newton Ltd
51 Rathbone Place
London W1

Paper specialists

Falkiner Fine Papers Ltd
4 Mart Street
off Floral Street
Covent Garden
London WC2E 8DE

USA

Arthur Brown and Bro Inc
2 West 46 Street
New York

The Morilla Company Inc
43 21st Street
Long Island City
New York
and 2866 West 7 Street
Los Angeles
California

Stafford-Reeves Inc
626 Greenwich Street
New York, NY 08701

Winsor and Newton Inc
555 Winsor Drive
Secaucus
New Jersey 07094

Paper specialists
Hobart Paper Co
11 West Washington Street
Chicago, Illinois 60600

Wellman Paper Co
308 West Broadway
New York, NY 10012

Index